HOCKEY IN PROVIDENCE

D1238799

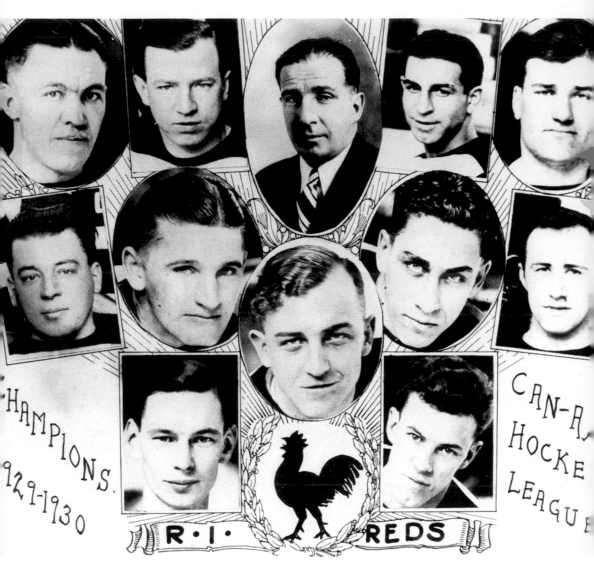

FONTAINE CUP CHAMPION REDS, 1929–1930. Shown here from left to right are (first row) Jack McVicar and Art Chapman; (second row) Gizzy Hart, Hago Harrington, Ludger Desmarais, Leo Gaudreault, and Roger Cormier; (third row) Mickey Murray, Leo Murray, Sprague Cleghorn (coach), Johnny Gagnon, and Art Lesieur.

FRONT COVER: **ZELLIO TOPPAZZINI.** Seen here is Zellio Toppazzini of the Providence Reds. (Courtesy of the Rhode Island Reds Heritage Society.)

COVER BACKGROUND: Please see page 14. (Courtesy of the Rhode Island Reds Heritage Society.)

BACK COVER: Please see page 100. (Courtesy of the Providence Bruins.)

HOCKEY IN PROVIDENCE

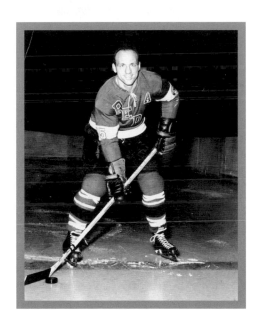

Jim Mancuso

ARCADIA
PUBLISHING

Copyright © 2006 by Jim Mancuso
ISBN 0-7385-4531-7

Published by Arcadia Publishing
Charleston SC, Chicago IL, Portsmouth NH, San Francisco CA

Printed in the United States of America

Library of Congress Catalog Card Number: 2006923086

For all general information contact Arcadia Publishing at:
Telephone 843-853-2070
Fax 843-853-0044
E-mail sales@arcadiapublishing.com
For customer service and orders:
Toll-Free 1-888-313-2665

Visit us on the Internet at www.arcadiapublishing.com

In memory of Zellio Toppazzini, the Rhode Island Reds Heritage

Society's Reds player of the century and one of the greatest

players in American Hockey League history.

CONTENTS

ACKNOWLEDGMENTS

The images in this book are courtesy of the American Hockey League, Tom Army, Buster Clegg, Ernie Fitzsimmons, Roger Gladu, Lauren Peterson (executive assistant to the president of the American Hockey League), the Providence Bruins, the Rhode Island Reds Heritage Society, Tom Sersha (executive director of the United States Hockey Hall of Fame), and the United States Hockey Hall of Fame. Though the photographs were not obtained from them directly, credit is due to Providence Bruins photographers Ron Marcotte and David Silverman, who were responsible for actually taking some of the photographs featured in this publication.

I would like to thank the American Hockey League, Kevin Boryczki (Providence Bruins manager of public relations), Ernie Fitzsimmons, and Edwin Duane Isenberg for their imaging work on the illustrations in this book.

I was helped directly through the Providence Bruins office by Frank DuRoss (team president and owner) and Kevin Boryczki (manager of public relations).

I was helped directly through the Rhode Island Reds Heritage Society by founding president Buster Clegg, Tom Army, and George Patrick Duffy.

The statistics in this book were obtained from the *2006 National Hockey League Official Guide and Record Book*, the *National (Official) Hockey Guide* edited by Jim Hendy (various years), Ralph Slate's Hockey Database (www.hockeydb.com), the Society for International Hockey Research, and *Total Hockey (Second Edition)—The Official Encyclopedia of the National Hockey League*.

Other resources used to complete this work include *The American Hockey League Official Guide and Record Book* (various years); Ray Clow; Ernie Fitzsimmons; *Hockey In Springfield* by Jim Mancuso; *The Hockey News* (various years); *The Providence Journal* (various years); The Rhode Island Reds Heritage Society (www.rireds.org); *The Sporting News Hockey Guide* (various years); and Fred Zalatan.

A special thanks to my mother Joan Mancuso, ticket sales representative at the Utica Memorial Auditorium, who got me in free to hockey games in the 1970s and early 1980s.

INTRODUCTION

Providence iced its first professional hockey team over 80 years ago. The tradition started in 1926–1927 when the Providence Reds were inaugural members of the Canadian American Hockey League (CAHL). The CAHL was organized in Boston on August 17, 1926, and was affiliated with the National Hockey League (NHL). The Reds were a farm team of the Montreal Canadiens during all 10 seasons of the CAHL from 1926–1927 to 1935–1936. Hector "Toe" Blake, Emile "Butch" Bouchard, Johnny Gagnon, Leo Gaudreault, Art Giroux, Wilfred "Gizzy" Hart, Wildor Larochelle, Art Lesieur, Armand Mondou, Leo Murray, and Gus Rivers were among the players assigned to Providence by the Canadiens (NHL). The Reds share the CAHL all-time record for winning the most Fontaine Cup playoff championships with three (1929–1930, 1931–1932, and 1933–1934).

In 1936–1937, Providence helped form the American Hockey League (known as the International-American Hockey League from 1936 to 1940). The locals won two Calder Cups, 1937–1938 and 1939–1940, during the new league's first four seasons. Both championships were won under coach Fred "Bun" Cook. The Reds formed a working agreement with the Boston Bruins from 1936–1937 to 1938–1939. Bobby Bauer, Frank Brimsek, Jack Crawford, Woody Dumart, Robert "Red" Hamill, Mel Hill, Jim "Peggy" O'Neil, Milt Schmidt, and Jack Shewchuck were assigned to Providence by Boston. From 1938–1939 to 1940–1941, the Reds had ties to the Chicago Black Hawks, and Max Bentley, Mike Karakas, John Mariucci, and Bill Mosienko skated for Providence by way of Chicago. Providence was also affiliated with the Maple Leafs (NHL) in 1940–1941.

From 1941–1942 to 1945–1946, the Reds acquired players from several NHL teams, with a majority of NHL surplus coming from Toronto in 1942–1943, Chicago in 1943–1944 and 1944–1945, and the Rangers in 1945–1946. Providence did not have an NHL affiliation from 1946–1947 to 1954–1955. In 1948–1949, however, the locals won their third Calder Cup title under player/coach Terry Reardon. Carl Liscombe, who became the first player in American Hockey League (AHL) history to break the 100-point plateau a year before, set the Reds' all-time single-season goal record with 55 tallies in 1948–1949. Harvey Bennett led the team between the pipes with a league leading 43 wins and a 3.16 goals against average (GAA) in 1948–1949.

In 1955–1956, the Reds captured their fourth Calder Cup as they began a three-year affiliation with the New York Rangers. Zellio Toppazzini captured the John B. Sollenberger Trophy as the AHL's leading scoring, and Johnny Bower received the Les Cunningham Award as the league's regular season MVP that banner season.

For the next seven seasons, from 1958–1959 to 1964–1965, the Reds established an affiliation with the Boston Bruins. The locals captured a division title in 1962–1963 but did not win a playoff round during this "Bruin" era.

Providence was independent of an NHL affiliation from 1965–1966 to 1968–1969. The NHL's Seals were the Reds' parent team in 1969–1970 and 1970–1971. The locals made their first Calder Cup finals appearance in 15 seasons in 1970–1971 and also captured their first division title in eight years under coach Larry Wilson.

The New York Rangers became Providence's parent team for the next five seasons from 1971–1972 to 1975–1976 (having a split affiliation with the St. Louis Blues in 1975–1976). Ron Greschner, Dave Maloney, and Rick Middleton arrived in town courtesy of the Rangers (NHL). The Reds made the playoffs in each of those seasons, reaching the Calder Cup finals in 1973–1974 and securing their 10th AHL first-place finish in 1974–1975 by capturing their division. Coach John Muckler won the Louis A. R. Pieri Memorial Award as the AHL's coach of the year in 1974–1975 as he led the Reds to their sixth AHL regular season title.

In 1976–1977, the locals became officially known as the Rhode Island Reds. The Colorado Rockies (NHL) and New England Whalers of the World Hockey Association (WHA) shared an affiliation with Rhode Island. The Reds suffered one of their worst seasons in team history and missed the postseason for the first time in seven years. It would also be the last season of the 51-year-old Reds franchise, as the club was sold and moved to Binghamton, New York.

Professional hockey returned to Providence in 1992–1993 with the birth of the Providence Bruins. The "P-Bruins," as they were fittingly nicknamed, carry on the city's great hockey legacy. In 1998–1999, the team captured the Calder Cup and the AHL regular season title. In their history, the Bruins (AHL) have also won three division titles and made the postseason in 12 of their 14 campaigns. Players assigned to Providence by Boston (NHL) included Rod Langway (two-time James Norris Memorial Trophy winner as the NHL's best defenseman in 1982–1983 and 1983–1984), Jim Carey (the Vezina Trophy winner as the NHL's best goaltender in 1995–1996), Andrew Raycroft (the Calder Memorial Trophy winner as the NHL's rookie of the year in 2003–2004), and Boston's number one draft picks Glen Murray (1991 NHL Entry Draft) and Hannu Toivonen (2002 NHL Entry Draft).

Several P-Bruins have won AHL awards, including Randy Robitaille (the AHL's regular season MVP in 1998–1999), Peter Ferraro (the Jack Butterfield Trophy winner as the AHL's playoff MVP in 1998–1999), Peter Laviolette (the AHL's coach of the year in 1998–1999), and Jeff Serowik (the Eddie Shore Award winner as the AHL's outstanding defenseman in 1994–1995). The P-Bruins also iced several AHL All-Stars and members of the AHL's all-rookie team. In 1994–1995, Providence hosted the first AHL All-Star game in 35 seasons.

The Providence Bruins have provided area fans with a high caliber of hockey and have established themselves as one of the top sporting attractions in Providence as well as the state of Rhode Island. Providence truly has one of the richest traditions in hockey history.

THE CANADIAN AMERICAN HOCKEY LEAGUE

Professional hockey was born in Providence when the Providence Reds became inaugural members of the Canadian American Hockey League (CAHL) in 1926–1927. Judge James E. Dooley owned the club, and Jean Dubuc was the team's general manager. The club played at the Rhode Island Auditorium. Jimmy Gardner was named coach, and the Reds became a farm team of the Montreal Canadiens (NHL). In its 10-year history, the CAHL had a single-division format. Providence finished in last place out of five in 1926–1927 with a 12-17-3 record. Wilfred Desy led the club in goals (10) and points (11) that first season while tying for seventh in goals and tying for eighth in points in CAHL scoring.

In 1927–1928, the Reds finished fifth out of six with a 13-19-8 record and failed to make the postseason again. Johnny Gagnon placed second in goals (20) and tied for third in points (24) in the CAHL, while Armand Mondou placed seventh in league scoring with 21 points.

Providence qualified for the playoffs for the first time in 1928–1929, placing second out of six teams and posting its first winning record—18-12-10. The CAHL playoff format (with the exception of 1931–1932, when the first-place team played the third, and the second-place team played the fourth) had the second and third place teams face off to meet the first place team for the Henri Fontaine Cup (named in honor of the president and owner of the Quebec CAHL franchise who passed away in the middle of the loop's inaugural season; the trophy was dedicated in his memory). The Reds beat the New Haven Eagles four goals to three in a two-game total goals series to advance to their first finals appearance. The Reds faced the Boston Tigers for the Fontaine Cup championship in a four-game series (two home games each) where total goals would count in case of a tie. Boston won the championship two games to none with two tie games. Art Chapman placed second in the CAHL in points (28) and led the league in assists (14), while Mickey Murray posted a 1.37 GAA and led the CAHL in shutouts (12).

The Reds won their first Fontaine Cup championship in 1929–1930. Providence finished in first place with a 24-11-5 record and was given a direct berth into the finals where they defeated Boston three games to none. Jimmy Gardner began the campaign as coach and was replaced early in the season by Sprague Cleghorn. Reds general manager Jean Dubuc served as interim coach for one game (a loss) prior to Sprague Cleghorn's arrival. Art Chapman (third place with 45 points), Johnny Gagnon (sixth place with 38 points), and Gizzy Hart (tied for seventh place with 36 points) were among the CAHL scoring leaders. Mickey Murray led the CAHL in wins (23), GAA (2.41), and shutouts (6).

In 1930–1931, Providence secured a third consecutive winning season with a 23-11-6 record and finished in second. Boston, however, defeated Sprague Cleghorn's team seven goals to six in a two-game total goals series and earned a berth in the finals. Leo Gaudreault (second place with 42 points), Gizzy Hart (tied for third place with 38 points), and Sparky Vail (fifth place with 33 points) were some of the league's top scorers that season. Mickey Murray led the CAHL in GAA (2.33) and shutouts (4).

Newsy Lalonde became the club's new coach in 1931–1932, and Providence captured a second Fontaine Cup championship and regular season title (23-11-6 record). The Reds beat the Bronx Tigers in the semifinals five goals to two in a two-game total goals series, and they defeated the Boston Cubs (formerly known as the Tigers) in the finals three games to none. Four Reds placed in the CAHL top 10 in scoring—Gizzy Hart (second place with 38 points), Hago Harrington (third place with 35 points), Leo Gaudreault (tied for seventh place with 28 points), and Leo Murray (tied for seventh place with 28 points). Bill Beveridge led the CAHL in wins (23) and led the team in GAA (2.58).

In 1932–1933, the Reds finished in second place with a 26-16-6 record behind new coach Billy Coutu, who would pilot the team through the 1934–1935 season. Providence lost to Boston in the semifinals seven goals to four in a two-game total goals series. Art Alexandre led the team in points (34), and Leo Murray tallied the most goals (16) for the Reds that season.

Providence captured its third Fontaine Cup championship and third regular season title (19-12-9 record) in 1933–1934. The Reds swept Boston three games to none in the finals. Art Giroux was third in CAHL scoring with 35 points, while Hago Harrington and Leo Gaudreault tied for fifth place in league scoring with 32 points. Paddy Byrne led the team with a 1.91 GAA and eight shutouts.

In 1934–1935, the Reds qualified for the postseason for the seventh straight year and achieved their seventh consecutive winning season with a third place 19-17-12 record. Providence beat the Quebec Castors in the semifinals two games to one but was swept by Boston (now known as the Bruin Cubs) in the finals three games to none. In league scoring, Leo Gaudreault and Hago Harrington tied for fifth place with 49 points, Gerry Lowrey ranked eighth with 44 points, and Gus Rivers ranked ninth with 41 points.

Prior to the 1935–1936 season, Albert "Battleship" Leduc was named player/coach of the team. The Reds responded with a second place finish and a 21-20-6 record. Providence defeated the Springfield Indians two games to one in the semifinals but succumbed in the finals to the Philadelphia Ramblers three games to one. Gus Rivers led the team in points (30) and goals (13).

Providence shares the record for the most Fontaine Cup championships in CAHL history with three (tied with Boston and Springfield). The Reds won the most CAHL regular season titles with three and compiled the best all-time regular season record in the history of the CAHL—198-146-71 (.563).

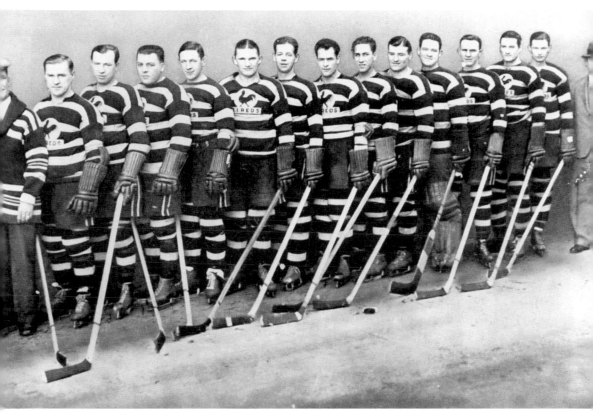

FONTAINE CUP CHAMPION REDS, 1933-1934. Pictured here from left to right are Edward Dubuc (trainer), Art Alexandre, Leo Murray, Gizzy Hart, Bob Taylor, Hago Harrington, George Nichols, Art Giroux, Leo Gaudreault, Art Lesieur, Paddy Byrne, Gus Rivers, Andy Mulligan, Jack McVicar, and Billy Coutu (coach).

ART LESIEUR (DEFENSE). One of three Reds players with 12 years of service, Lesieur skated on more championship teams with Providence that anyone else, with five (1930, 1932, 1934, 1938, and 1940). In his dozen campaigns with the club (1927–1935 and 1936–1940), he amassed 487 penalties in minutes (PIM), 89 points, and 50 assists in 412 games (10th most in team history). Lesieur played for the Stanley Cup–winning Canadiens (NHL) in 1930–1931.

LEO GAUDREAULT (CENTER/LEFT WING).
He was a member of all three Reds Fontaine
Cup championship teams. The forward
produced 223 points, 95 goals, and 235 PIM
in 307 games during his eight seasons with
Providence from 1928 to 1936. Gaudreault
spent three years in the NHL between 1927
and 1933 and tallied 12 points and 8 goals in
67 games. He is the CAHL's all-time leader in
assists (128).

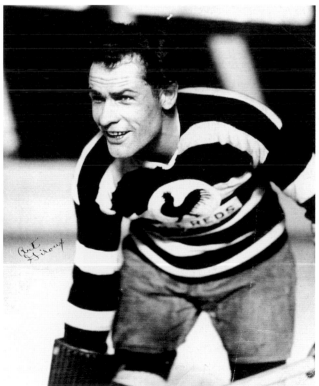

ART GIROUX (RIGHT WING).
Giroux was a member of four
Reds championship teams: two
Fontaine Cups (1931–1932 and
1933–1934) and two Calder Cups
(1937–1938 and 1939–1940). He
also won a Fontaine Cup with
Boston in 1934–1935 and a Teddy
Oke Trophy with Detroit of the
International Hockey League
(IHL) in 1935–1936. In his nine
seasons with Providence
(1930–1934, 1937–1941, and
1943–1944), Giroux amassed
255 points and 136 goals in
348 games.

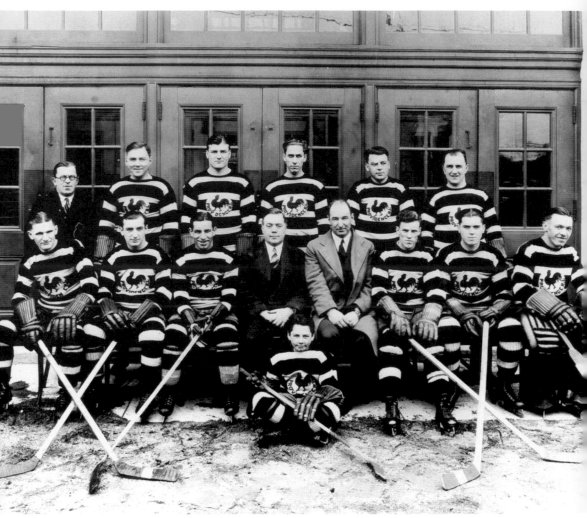

PROVIDENCE REDS, 1928–1929. Pictured here from left to right are (first row) Hago Harrington, Wildor Larochelle, Johnny Gagnon, Judge James E. Dooley (owner), Jean Dubuc (general manager), Art Chapman, Archie Wilcox, and Mickey Murray; (second row) Steve Davis (trainer), Roland Paulhus, Art Lesieur, Leo Gaudreault, Gizzy Hart, and Charlie Langlois. The child seated on the ground is Art Chapman Jr. (mascot).

ART CHAPMAN (CENTER). Chapman garnered 73 points and 40 goals in 77 games during his two seasons with Providence from 1928 to 1930. He was a member of the Reds' 1929–1930 Fontaine Cup championship team, and he also won a Fontaine Cup with Springfield in 1927–1928. In 10 NHL campaigns from 1930 to 1940, the center tallied 238 points and 176 assists in 438 games. Chapman coached Buffalo (AHL) to back-to-back Calder Cups in 1942–1943 and 1943–1944.

HAROLD "GIZZY" HART (LEFT WING). He was a member of all three Providence Fontaine Cup championship teams. Hart tallied 164 points, 103 goals, and 159 PIM in 240 games during his six seasons with the Reds from 1928 to 1934. The left-winger played three years in the NHL between 1926 and 1933 and garnered 14 points and 6 goals in 104 games. He was a member of Stanley Cup–winning Victoria in 1924–1925.

ROLAND PAULHUS (DEFENSE). A veteran of four seasons with Providence from 1926 to 1930, Paulhus accumulated 264 PIM, 33 points, and 25 goals in 114 games. He skated in 33 games with Montreal (NHL) in 1925–1926. The defenseman also played in the CAHL with New Haven in 1929–1930 and Philadelphia from 1930 to 1932.

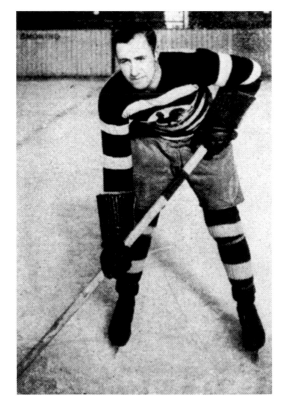

ROGER CORMIER (RIGHT WING). Cormier was a member of two Providence Fontaine Cup–winning teams in 1929–1930 and 1931–1932. The right-winger spent six seasons with the Reds from 1926 to 1932, garnering 71 points, 40 goals, and 261 PIM in 216 games. He skated in the IHL for five seasons between 1928 and 1936. The IHL was known as the Canadian Professional Hockey League (CPHL) from 1926 to 1929.

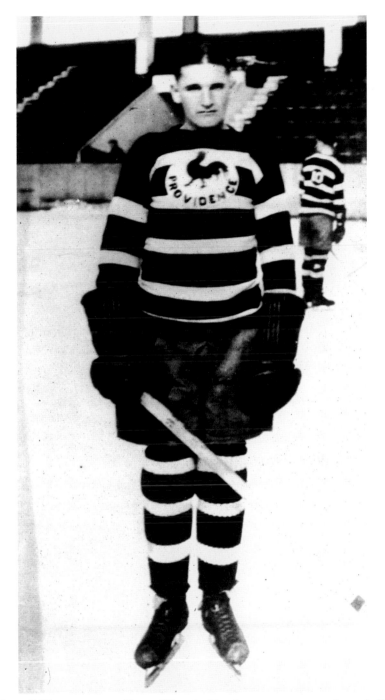

LELAND "HAGO" HARRINGTON (LEFT WING). Harrington was a member of all three Reds Fontaine Cup championship teams. In his eight years with the club from 1928 to 1936, he had 203 points, 92 goals, and 280 PIM in 299 games. A veteran of three NHL campaigns between 1925 and 1933, the left-winger tallied 12 points and 9 goals in 72 games. Hago is the CAHL's all-time leader in points (246) and goals (126).

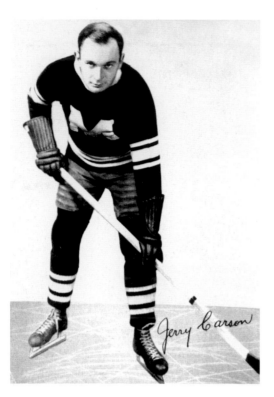

GERALD CARSON (DEFENSE). Carson skated for Providence Fontaine Cup championship teams in 1929–1930 and 1931–1932. In three seasons with the Reds from 1929 to 1932, the defenseman totaled 21 points, 14 goals, and 180 PIM in 84 games. A veteran of six NHL campaigns between 1928 and 1937, he produced 23 points, 12 goals, and 205 PIM in 261 games.

ARMAND MONDOU (LEFT WING). A veteran of 12 NHL seasons from 1928 to 1940, Mondou notched 118 points, 71 assists, and 99 PIM in 386 games. He was a member of the Canadiens' (NHL) Stanley Cup–winning teams of 1929–1930 and 1930–1931. The left-winger spent five campaigns with Providence (1926–1929, 1932–1933, and 1934–1935) and produced 49 points, 29 goals, and 109 PIM in 106 games.

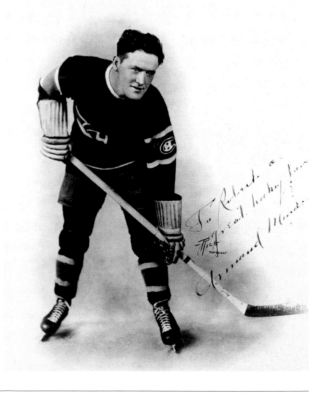

JIMMY GARDNER (COACH). Gardner was named the Reds first coach in 1926–1927 and piloted the club until the early part of the 1929–1930 season. He compiled a 46-52-21 (.475) record with Providence. As a player, the left-winger was a member of four Stanley Cup championship teams—the Montreal AAA in 1901–1902 and 1902–1903, and the Montreal Wanderers in 1908–1909 and 1909–1910.

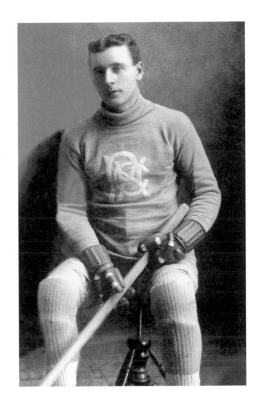

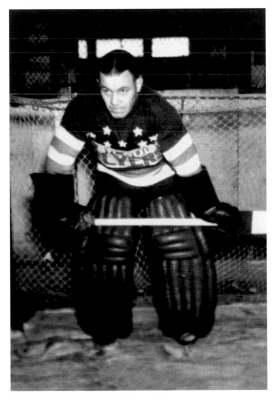

MICKEY MURRAY (GOALIE). Murray has the best all-time GAA (2.01) in Reds' history for any goalie appearing in over 100 games. He is also tied for first all-time in shutouts (23) in team history. In four campaigns with Providence from 1927 to 1931, the goaltender also had a 70-44-26 record in 140 games. He holds Reds' single-season records for GAA (1.37 in 1928–1929) and shutouts (12 in 1928–1929).

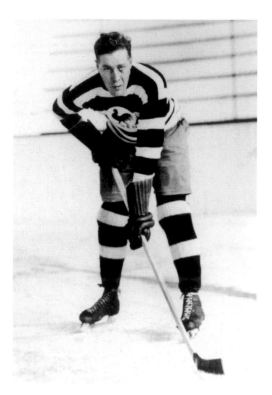

HARRY CONNOR (LEFT WING). In his two seasons with the Reds from 1931 to 1933, Connor had 40 points and 20 goals in 66 games. He was a member of Providence's 1931–1932 Fontaine Cup–winning team. The left-winger produced 21 points, 16 goals, and 149 PIM in 134 NHL games from 1927 to 1931.

ALBERT "BATTLESHIP" LEDUC (DEFENSE/COACH). Battleship was a member of the Canadiens' (NHL) first back-to-back Stanley Cup championship teams in 1929–1930 and 1930–1931. In his 10 NHL seasons from 1925 to 1935, the defenseman accumulated 614 PIM and 92 points in 383 games. Leduc was player/coach of the Reds from 1935 to 1937 and tallied 30 points, 23 assists, and 130 PIM in 86 games, while compiling a 42-40-13 (.511) coaching record.

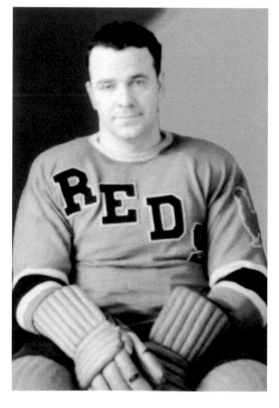

GORDON "DOGGIE" KUHN (RIGHT WING).
He had 131 points, 60 goals, and 164 PIM
in 240 games during his five seasons with
the Reds from 1934 to 1939. Kuhn was a
member of Providence's 1937–1938 Calder
Cup–winning team. The right-winger skated
in 12 NHL games and registered two points
and one goal.

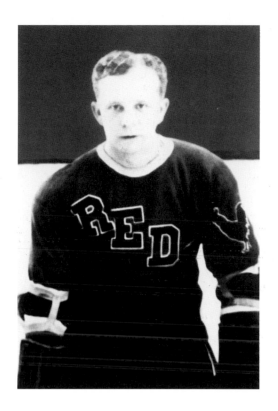

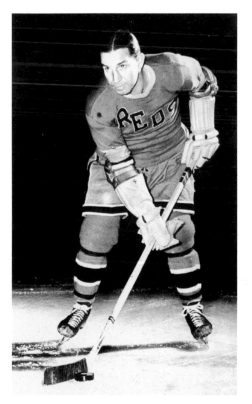

JOHNNY GAGNON (RIGHT WING). A veteran
of 10 NHL seasons from 1930 to 1940, Gagnon
produced 261 points, 120 goals, and 295 PIM
in 454 games. He won a Stanley Cup with the
Canadiens (NHL) in 1930–1931. The right-winger
spent five seasons with Providence (1927–1930,
1942–1943, and 1944–1945) and tallied 96
points and 57 goals in 176 games. Gagnon was
a member of the Reds' 1929–1930 Fontaine Cup
championship team.

ANDY MULLIGAN (DEFENSE). Mulligan skated for three seasons with the Reds from 1933 to 1936, garnering 33 points, 14 goals, and 144 PIM in 121 games. He was a member of Providence's 1933–1934 Fontaine Cup–winning team. The defenseman spent 10 seasons in the American Hockey Association (AHA) between 1928 and 1942, and he won a Sinclair Trophy championship with Minneapolis (AHA) in 1936–1937.

JACK MCVICAR (DEFENSE). He was a member of two Reds' Fontaine Cup teams in 1929–1930 and 1933–1934. McVicar played three seasons with Providence (1929–1930 and 1932–1934) and tallied 32 points, 18 goals, and 179 PIM in 106 games. The defenseman skated in two NHL seasons from 1930 to 1932 and garnered six points, two goals, and 63 PIM in 88 games.

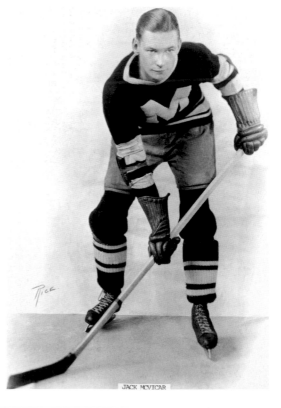

JACK MCVICAR

BILL BEVERIDGE (GOALIE). The goaltender had a 2.60 GAA, a 25-16-6 record, and six shutouts in 47 games during three seasons with Providence (1931–1933 and 1938–1939). He was a member of the Reds' 1931–1932 Fontaine Cup–winning team and led the CAHL in wins with 23 that season. Beveridge spent nine seasons in the NHL between 1929 and 1943, compiling a 2.87 GAA and 18 shutouts in 297 games.

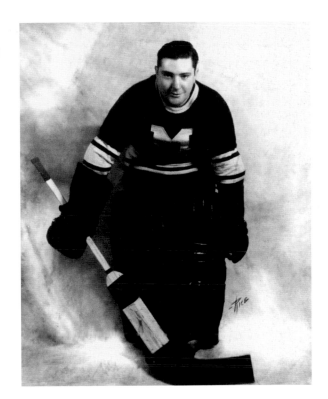

MELVILLE "SPARKY" VAIL (DEFENSE/LEFT WING). Sparky garnered 76 points, 51 assists, and 104 PIM in 115 games during three campaigns with Providence from 1930 to 1933. He was a member of the Reds' 1931–1932 Fontaine Cup championship team and also won two Fontaine Cups with Springfield (1926–1927 and 1927–1928). In two NHL seasons from 1928 to 1930, he had five points and 18 PIM in 50 games.

GUS RIVERS (RIGHT WING). Rivers won two Stanley Cups with the Canadiens (NHL), in 1929–1930 and 1930–1931, and two Fontaine Cups with Providence, in 1931–1932 and 1933–1934. In six campaigns with the Reds from 1931 to 1937, the right-winger produced 164 points, 72 goals, and 102 PIM in 233 games. A veteran of three NHL seasons from 1929 to 1932, Rivers notched nine points, four goals, and 12 PIM in 88 games.

PADDY BYRNE (GOALIE). He helped lead the Reds to the 1933–1934 Fontaine Cup championship with a 1.91 GAA, a 19-12-9 record, and eight shutouts. Byrne played five seasons with Providence from 1932 to 1937 and earned a 2.53 GAA in 215 games. He shares the Reds' all-time team record for shutouts with 23. He spent time in the AHA from 1927 to 1932 and won a Skelly Cup championship with Kansas City (AHA) in 1929–1930.

2

THE EARLY AHL YEARS
AND TWO CALDER CUPS

In 1936–1937, the Canadian American Hockey League and the International Hockey League combined to form the International-American Hockey League (IAHL). The IAHL would become known as the American Hockey League (AHL) in 1940–1941. Albert "Battleship" Leduc remained as player/coach, and the Boston Bruins became the Reds' NHL affiliate. The new league operated in a two-division format in every season from 1936–1937 to 1951–1952, except in 1942–1943. The locals finished in third place in their division with a 21-20-7 record but lost in the first round of the playoffs against Springfield, two games to one.

The Reds became the second team to win the Calder Cup in 1937–1938. Providence finished in first place in its division that year with a 25-16-7 record under new coach Fred "Bun" Cook. Frank Brimsek (first team goalie), Walter Kalbfleisch (second team defenseman), Art Lesieur (second team defenseman), and Sam McManus (second team right wing) were named to the IAHL's All-Star team. Frank Brimsek's 1.79 GAA in 1937–1938 was the league's all-time single-season mark until it was broken in 2003–2004. In the postseason, the locals beat Philadelphia two games to one in the semifinals, and then defeated the Syracuse Stars in the finals, three games to one.

The locals' streak of 10 straight winning seasons was snapped in 1938–1939 with a 21-22-11 record and a second place divisional finish. Coach Bun Cook was named to the IAHL All-Star team, and Art Lesieur was named a second team all-star defenseman.

The Reds captured their second Calder Cup title in 1939–1940 and had the best regular season record in the IAHL (27-19-8). Bun Cook's team beat the Western Division–winning Indianapolis Capitols three games to two and received a direct berth in the finals (the league playoff format for some seasons had both division winners face off in the first round for a berth into the finals). Providence swept the Pittsburg Hornets in three straight games to win the championship. Bun Cook (coach), Art Giroux (second team right wing), and Bill MacKenzie (second team defenseman) were named to the IAHL All-Star team.

A second consecutive regular season crown was attained by the Reds in 1940–1941 with a 31-21-4 record. Bun Cook was named league all-star coach for the third season in a row. Goalie Mike Karakas and defenseman Doug Young were named to the first all-star team. The Western Division–winning Cleveland Barons ended the Reds' chances for a Calder Cup repeat by beating the locals three games to one in the semifinals.

In 1941–1942, Providence failed to make the playoffs for the first time since the 1927–1928 season, finishing in fourth place in their division with a 17-32-7 record. Bun Cook earned league all-star coaching honors once again despite the dismal year.

LOUIS A. R. PIERI (OWNER AND GENERAL MANAGER). Pieri owned the Reds from 1939–1940 until his death in the summer of 1967. In honor of Louis A. R. Pieri, the AHL instituted an annual coach of the year award in his name starting with the 1967–1968 season. Prior to owning the Reds, he was manager of the Rhode Island Auditorium from 1929–1930 until he bought the club in 1939–1940. As general manager of the Reds, he guided the club to three Calder Cup championships in 1937–1938, 1939–1940, and 1948–1949.

THE EARLY AHL YEARS AND TWO CALDER CUPS

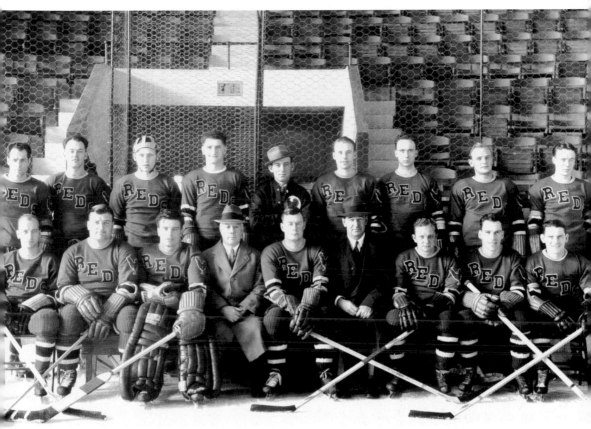

CALDER CUP CHAMPION REDS, 1937–1938. Shown here from left to right are (first row) Sammy McManus, Art Lesieur, Frank Brimsek, Judge James E. Dooley (owner), Fred "Bun" Cook (coach), Jean Dubuc (general manager), Doggie Kuhn, Jim Jarvis, and John Keating; (second row) Art Giroux, Lorin Mercer, Jack Crawford, Jack Shewchuck, George Army (trainer), Red Hamill, Alex Motter, Walter Kalbfleisch, and Mel Hill.

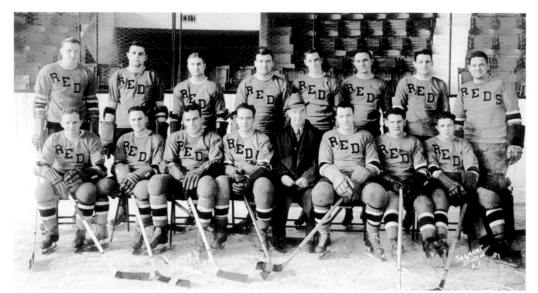

PROVIDENCE REDS, 1936–1937. Pictured here from left to right are (first row) Doggie Kuhn, Gerry Lowrey, Lorne Duguid, Alex Motter, Jean Dubuc (general manager), Albert Leduc (coach), John Keating, and Bobby Bauer; (second row) Bob McCulley, Woody Dumart, Bert McInenly, Art Lesieur, Milt Schmidt, Gus Rivers, Red Conn, and Paddy Byrne.

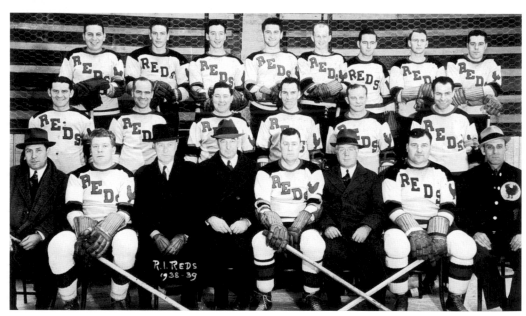

PROVIDENCE REDS, 1938–1939. Pictured here from left to right are (first row) Art Markey (announcer), John Doran, Dr. Frank Ryan (team physician), Jean Dubuc (general manager), Fred "Bun" Cook (coach), Judge James E. Dooley (owner), Art Lesieur, and George Army (trainer); (second row) John Keating, Crossley Sherwood, Bill Beveridge, Jim Jarvis, Doggie Kuhn, and Art Giroux; (third row) Wilf Starr, Harold Jackson, Ab DeMarco, Jack Shewchuck, Joe McGoldrick, Pat McReavy, Ron Hudson, and Hub Wilson.

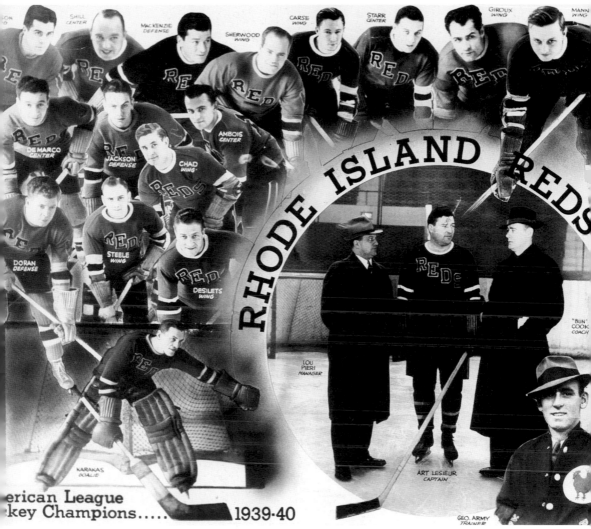

CALDER CUP CHAMPION REDS, 1939–1940. Shown here from left to right are (circle) Louis A. R. Pieri (general manager), Art Lesieur (captain), Fred "Bun" Cook (coach), and George Army (trainer); (first row) Mike Karakas; (second row) John Doran, Clarence Steele, and Joffre Desilets; (third row) Ab DeMarco, Harold Jackson, John Chad, and Eddie Ambois; (fourth row) Hub Wilson, Jack Shill, Bill MacKenzie, Crossley Sherwood, Bob Carse, Wilf Starr, Art Giroux, and Norm Mann.

JOHN "RED" DORAN (DEFENSE). In two seasons with Providence from 1938 to 1940, the defenseman accumulated 145 PIM, 45 points, and 16 goals in 79 games. A veteran of five NHL campaigns between 1933 and 1940, Doran garnered 15 points, 10 assists, and 110 PIM in 98 games.

JIM JARVIS (LEFT WING). Jarvis was a member of the Reds' 1937–1938 and 1939–1940 Calder Cup–winning teams. The left-winger had 54 points, 37 assists, and 24 PIM in 125 games during three years with Providence, from 1937 to 1940. He was a member of the first Calder Cup championship team with Syracuse in 1936–1937 and also skated for Teddy Oke Trophy–winning Buffalo (IHL) in 1932–1933.

ROBERT "RED" HAMILL (LEFT
WING). Red tallied 17 points, 8
goals, and 31 PIM in 40 games for
the 1937–1938 Calder Cup–winning
Reds. He played in 12 NHL seasons
between 1937 and 1951, producing
222 points, 128 goals, and 160 PIM
in 419 games.

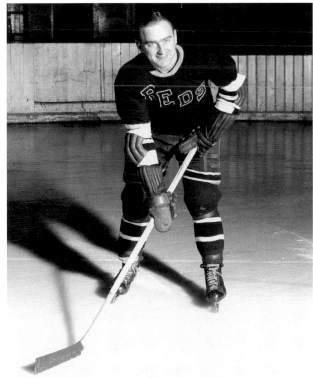

CLARENCE "WINDY" STEELE
(LEFT WING). Windy skated for
the Reds' 1939–1940 championship
team. In four seasons with
Providence from 1939 to 1943,
Steele produced 82 points, 34 goals,
and 89 PIM in 146 games. He also
played in the American League
with Hershey from 1938 to 1940
and Pittsburg in 1940–1941.

JAMES "HUB" WILSON (LEFT WING). During three seasons with Providence from 1938 to 1941, Hub registered 74 points, 37 goals, and 44 PIM in 126 games. He was a member of the Reds' 1939–1940 Calder Cup–winning team. The left-winger also played in the American League with Springfield from 1936 to 1939, Philadelphia in 1941–1942, and Pittsburg in 1941–1942, and he spent five seasons in the CAHL from 1931 to 1936.

CROSSLEY SHERWOOD (FORWARD). He was a member of Providence's 1939–1940 Calder Cup–winning team. A veteran of five campaigns with the Reds between 1938 and 1944, the forward produced 129 points, 45 goals, and 48 PIM in 236 games. Prior to arriving in Providence, Sherwood skated for Pittsburg (IAHL) in 1937–1938.

JOHN KEATING (LEFT WING). A veteran
of five seasons with Providence from 1934
to 1939, Keating had 151 points and 58
goals in 240 games. He was a member of
the Reds' 1937–1938 Calder Cup–winning
team. The left-winger spent two campaigns
in the NHL from 1931 to 1933, and he
notched 10 points, 5 goals, and 17 PIM in
35 games.

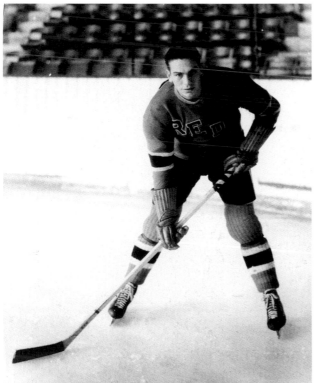

HAROLD JACKSON (DEFENSE). He
played for three seasons with the
Reds from 1938 to 1941, tallying 23
points, 15 assists, and 101 PIM in
97 games. Jackson was a member of
Providence's Calder Cup–winning
team in 1939–1940. A veteran of
eight NHL campaigns between
1936 and 1947, the defenseman
accumulated 208 PIM and 51
points in 219 games. He also won
a Calder Cup with Indianapolis
in 1941–1942.

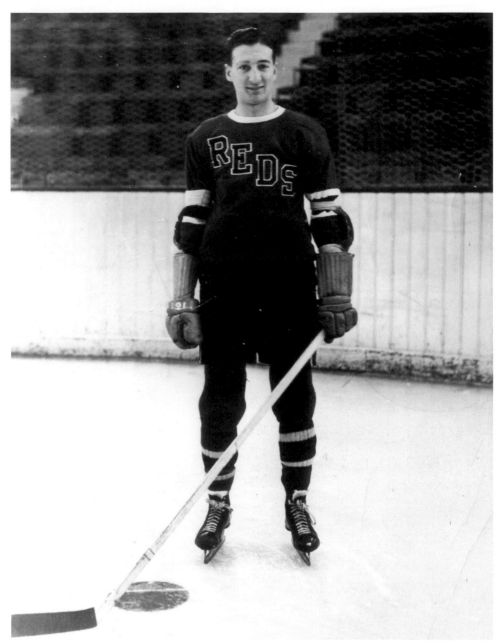

AB DeMARCO SR. (CENTER). He was a member of the Reds' 1939–1940 Calder Cup–winning team. In five seasons with the Reds from 1938 to 1943, DeMarco produced 213 points and 132 assists in 219 games. He was the AHL's regular season MVP and leading scorer in 1950–1951. A veteran of seven NHL campaigns between 1938 and 1947, the center tallied 165 points and 72 goals in 209 games. DeMarco was one of three players to lead the Reds in scoring during three different seasons—1940–1941, 1941–1942, and 1942–1943 (Zellio Toppazzini and Stan Baluik were the other two players). DeMarco, however, was the only player to lead the Reds in scoring in three consecutive seasons.

THE EARLY AHL YEARS AND TWO CALDER CUPS

JACK SHEWCHUCK (DEFENSE).
Shewchuck skated with Providence
from 1937 to 1939, tallying 32 points,
20 assists, and 141 PIM in 88 games.
The defenseman was a member of the
1937–1938 Reds' Calder Cup–winning
team. He spent six years in the NHL
between 1938 and 1945, producing 28
points, 19 assists, and 160 PIM in 187
games. Shewchuck played for Stanley
Cup–winning Boston in 1938–1939
and 1940–1941.

WILF STARR (CENTER). Starr was a
member of the Reds' 1937–1938 and
1939–1940 championship teams. He tallied
108 points and 72 assists in 134 games
with Providence from 1937 to 1940. In the NHL
from 1932 to 1936, the center had 14 points
and 8 goals in 87 games. Starr played for
two Teddy Oke Trophy–winning teams
with Detroit (1934–1935 and 1935–1936)
and one Fontaine Cup–winning team with
Springfield (1930–1931.)

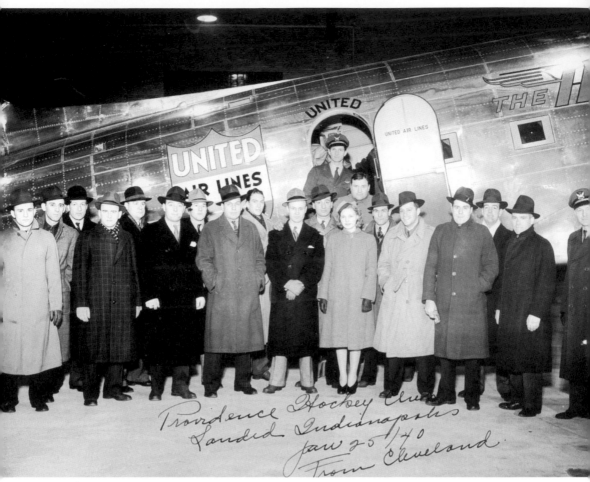

THE REDS AT INDIANAPOLIS ON A ROAD TRIP DURING THE 1939–1940 SEASON. Pictured here from left to right are Eddie Ambois, George Army (trainer), Joffre Desilets, Clarence Steele, Fred "Bun" Cook (coach), Jack Shill, Bill MacKenzie, Wilf Starr, Harold Jackson, Norm Mann, Ab DeMarco, John Treher (first officer on the stairs), Miss Bernice Wright (stewardess), Art Lesieur, Art Giroux, Armand Raymond, Hub Wilson, Phil Stein, Crossley Sherwood, and Captain Little (pilot).

3

THE GOLDEN AGE OF HOCKEY AND ANOTHER CHAMPIONSHIP

In 1942–1943, the National Hockey League (NHL) was down to six teams and began its "Original Six" era, which would last 25 years. The Original Six era of the NHL was characterized by a high caliber of play in the NHL, which trickled down to a high caliber of play and a low turnover in player personnel on the AHL level. During this period, AHL teams took on more character by having the same players year after year, and fans identified with players being associated with a specific team. This "Golden Era" would last until the 1966–1967 season as the NHL doubled in size to 12 teams in 1967–1968. The continuity of AHL team rosters and the caliber of players in the AHL would never be the same. The negative impact of major league expansion on the AHL became even more evident as the NHL gradually grew to 16 teams by 1974–1975 and with the arrival of the WHA in 1972–1973. The "Golden Age" of NHL and AHL hockey was great for those fans who experienced that era.

The 1942–1943 season was Bun Cook's last campaign behind the bench for Providence. Bun Cook was named to the AHL All-Star team for the fifth consecutive season as he returned the Reds to the postseason with a 27-27-2 record. Providence placed fifth out of eight teams in the AHL's single-division format. The locals lost in the first round of the playoffs against Cleveland two games to none. Goaltender Mike Karakas earned second team all-star honors.

The AHL returned to a two-division alignment in 1943–1944. With Bun Cook gone, the Reds suffered through four consecutive losing seasons from 1943–1944 to 1946–1947, missing the postseason in every year but 1945–1946. Johnny Mitchell coached the team in 1943–1944 to an 11-36-5 last place divisional finish. In 1944–1945 and 1945-1946, Irwin "Yank" Boyd piloted the team. The Reds finished last in their division during Yank Boyd's first year with a 23-31-6 mark but managed to make the postseason in his second season finishing in third place in their division going 23-33-6. The locals' 1945–1946 playoff run was short-lived, losing in the first round to Cleveland two games to none. Tony Savage was named new coach in 1946–1947 and guided the team to a 21-33-10 record and a fourth place finish in its division.

The Reds were back on top in 1947–1948, winning their division with a 41-23-4 record under new player/coach Terry Reardon. Carl Liscombe became the first player in AHL history to crack 100 points in a single-season with 118 (which is also the Reds' all-time single-season point record). Also the first Reds player to score 50 goals in a single-season in 1947–1948, Liscombe

won the Wally Kilrea Trophy as the AHL's regular season point leader, was named AHL regular season MVP, and was selected a first team all-star at left wing. Having broken Wally Kilrea's AHL single-season point total in 1947–1948, the AHL renamed the leading scorer trophy the Carl Liscombe Trophy the following season. (From the 1955–1956 season to the present, the AHL's leading scorer trophy has been known as the John B. Sollenberger Trophy.) In the 1947–1948 postseason, Providence lost four games to one in the semifinals against Western Division–winning Cleveland.

Providence won its third Calder Cup championship in 1948–1949 after having the best regular season record in the AHL at 44-18-6. Carl Liscombe, who set the Reds' all-time single-season goal mark of 55 that season, was again named AHL regular season MVP and was given a second team all-star selection at left wing. Harvey Fraser was also a second team all-star at center. The locals had to take two playoff series the distance to secure the AHL crown—edging the Western Division–winning St. Louis Flyers in seven games in the semifinals and then coming back from a three-to-one deficit against the Hershey Bears to win the finals in seven games.

A third consecutive winning season was attained in 1949–1950 with a 34-33-3 record and a second place divisional finish. Terry Reardon's team swept Springfield in two games in the first round but then lost two games to none against Indianapolis in the semifinals.

The Reds hit a skid in the early 1950s. The club posted five straight losing seasons from 1950–1951 to 1954–1955 and missed the playoffs in four of those five campaigns. In 1950–1951, the locals finished in fourth place in their division, going 24-41-5. Despite having a 32-33-3 record in 1951–1952 (second place finish), Providence surprised everyone in the postseason by making it all the way to the Calder Cup finals. The Reds beat Cleveland in the first round three games to two and defeated the Cincinnati Mohawks three games to one in the semifinals. The Cinderella story came to an end in the finals against Pittsburg, losing four games to two. In 1951–1952, AHL regular season MVP Ray Powell led the league in scoring and was named a first team all-star at center. Right-winger Barry Sullivan was named a second team all-star that season.

In Terry Reardon's last season at the coaching reigns in 1952–1953, the Reds finished in fifth place with a 27-36-1 mark (from 1952–1953 to 1960–1961, the AHL operated in a single-division). Pat Egan was player/coach of Providence in 1953–1954 and 1954–1955, and the club finished in fifth place with a 26-40-4 record and last place with a 21-37-6 record respectfully. Zellio Toppazzini tied for a right wing spot on the second team all-stars in 1954–1955.

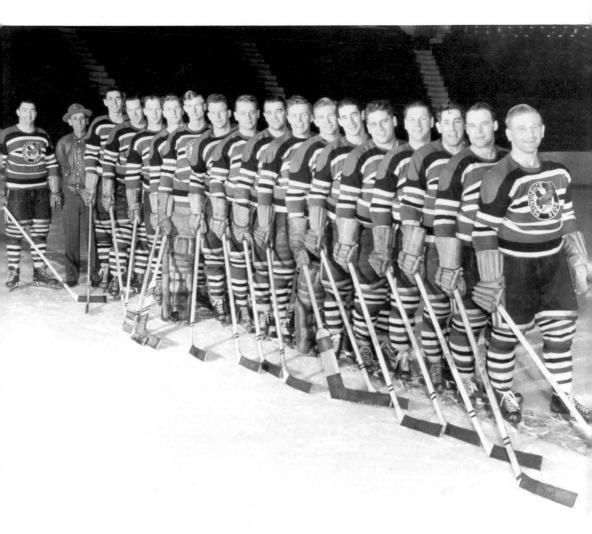

CALDER CUP CHAMPION REDS, 1948-1949. Pictured here from left to right are Terry Reardon (coach), George Army (trainer), Jack Stoddard, Jack McGill, Art Michaluk, Pete Kapusta, Harvey Bennett, Danny Summers, Bob Paul, Chuck Scherza, Harvey Fraser, Al Bentley, Roger Bedard, Moe Morris, Carl Liscombe, Jack Hamilton, Billy Arcand, and Eddie Kullman.

CARL LISCOMBE (LEFT WING). Liscombe is 10th all-time in goals (137) in Reds' history. In four seasons with Providence from 1946 to 1950, the left-winger produced 303 points and 166 assists in 219 games. An NHL veteran from 1937 to 1946, he tallied 277 points and 137 goals. Liscombe won a Stanley Cup with Detroit in 1942–1943 and a Calder Cup with Providence in 1948–1949.

HARVEY BENNETT (GOALIE).
Bennett played more seasons (12),
played more games between the pipes
(480), and registered more wins (226)
than any other Reds goaltender. He
compiled a 3.61 GAA, a 226-224-30
record and posted 10 shutouts from
1947 to 1959 with Providence. The
goaltender was a member of the Reds'
1948–1949 championship team. In
his only NHL season in 1944–1945,
Bennett had a 4.20 GAA in 25 games.

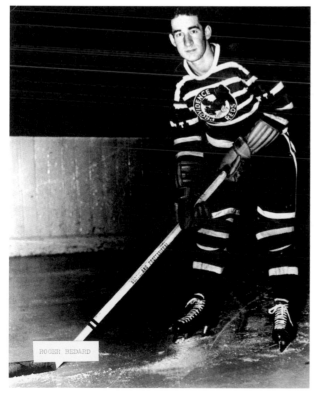

ROGER BEDARD (CENTER). Bedard
is 10th all-time in points (330)
and 10th all-time in assists (197)
in Reds' history. He scored 133
goals and registered 298 PIM in 375
games during eight seasons with
Providence from 1944 to 1952. The
center also skated in the AHL with
Cincinnati in 1950–1951 and spent
one season in the Quebec Hockey
League (QHL) in 1952–1953.

PETE KAPUSTA (LEFT WING). He is third all-time in points (465), fourth all-time in goals (194), fourth all-time in games (517), and fifth all-time in assists (271) in Reds' history. Kapusta skated for nine seasons with Providence from 1946 to 1955 and was a member of the club's 1948–1949 championship team. The left-winger also skated in the QHL, United States Hockey League (USHL), and Western Hockey League (WHL).

CHUCK SCHERZA (LEFT WING/CENTER). Scherza is second all-time in games (649), third all-time in assists (297), fourth all-time in points (436), and ninth all-time in goals (139) in Reds' history. He also racked-up 539 PIM during 10 campaigns with Providence from 1945 to 1955. Scherza won a Calder Cup with the Reds in 1948–1949. In two NHL seasons from 1943 to 1945, the forward registered 12 points and 6 goals in 36 games.

JOHN CHAD (RIGHT WING). He is fifth all-time in goals (168), seventh all-time in points (391), and eighth all-time in assists (223) in Reds' history. Chad was a member of two Providence Calder Cup teams—1939–1940 and 1948–1949—during his six seasons with the club (1939–1940 and 1946–1951). He played in 320 games with the Reds. The right-winger spent three seasons in the NHL between 1939 and 1946, registering 37 points in 80 games.

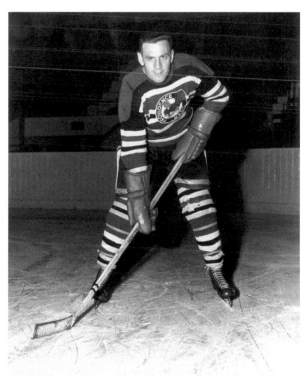

RAYMOND LaPLANTE (CENTER). He is fourth all-time in assists (281), sixth all-time in points (425), eighth all-time in goals (144), and eighth all-time in games (425) in Reds' history. LaPlante skated for Providence from 1946 to 1953 and was a member of the club's 1948–1949 championship team. The center was a member of O'Connell Trophy–winning Montreal (QHL) in 1955–1956.

TERRY REARDON (FORWARD/ COACH/GENERAL MANAGER). He compiled a 202-184-22 (.522) record and captured a Calder Cup title as Reds player/coach from 1947 to 1953. In 1954–1955, Reardon returned to the Reds as a player. The center/right wing registered 77 points, 61 assists, and 89 PIM in 273 games during seven seasons with Providence. A veteran of seven NHL campaigns between 1938 and 1947, Reardon tallied 100 points and 53 assists in 193 games.

HARVEY FRASER (CENTER). He was a member of Providence's 1948–1949 Calder Cup team. In five seasons with the Reds (1944–1945 and 1946–1950), Fraser tallied 265 points and 152 assists in 207 games. The center skated for Calder Cup–winning Cleveland in 1944–1945. Fraser spent one season in the NHL in 1944–1945 and garnered nine points and five goals in 21 games.

ELWYN "MOE" MORRIS (DEFENSE).
Moe skated in five campaigns with
Providence from 1948 to 1953,
producing 89 points, 73 assists,
and 76 PIM in 290 games. The
defenseman spent four seasons in
the NHL between 1943 and 1949
and collected 42 points and 29
assists in 135 games. He played with
Stanley Cup–winning Toronto in
1944–1945 and Calder Cup–winning
Providence in 1948–1949.

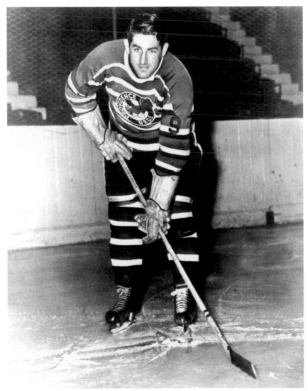

JACK HAMILTON (CENTER). In three
seasons with Providence from 1948 to
1951, the center produced 181 points
and 115 assists in 159 games. He was
a member of the Reds' 1948–1949
Calder Cup–winning team. A
veteran of three NHL campaigns
between 1942 and 1946, Hamilton
collected 60 points and 28 goals in
102 games.

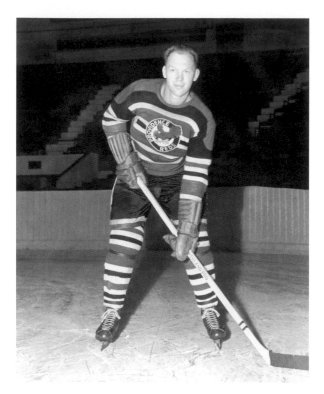

ART MICHALUK (DEFENSE). In five seasons with the Reds from 1947 to 1952, Michaluk garnered 116 points, 83 assists, and 194 PIM in 303 games. The defenseman had a stint in the NHL in 1947–1948. He was a member of Providence's Calder Cup–winning team in 1948–1949, and he won a President's Cup with Calgary (WHL) in 1953–1954.

JACK McGILL (CENTER). McGill is ninth all-time in assists (214) in Reds' history. The center tallied 313 points, 99 goals, and 229 PIM in 234 games during four campaigns with Providence from 1948 to 1952. A veteran of four NHL seasons between 1941 and 1947, he collected 59 points and 36 assists in 97 games. McGill skated for Calder Cup–winning teams in Hershey in 1946–1947 and Providence in 1948–1949.

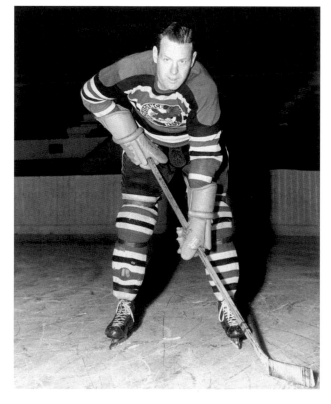

MAURICE "BILLY" ARCAND (DEFENSE). Arcand was a member of the Reds' 1948–1949 Calder Cup–winning team. In four seasons with Providence from 1946 to 1950, the defenseman tallied 90 points, 69 assists, and 209 PIM in 253 games. Billy also skated in the Quebec Senior Hockey League (QSHL) between 1945 and 1953 and the Maritime Major Hockey League (MMHL) in 1953–1954.

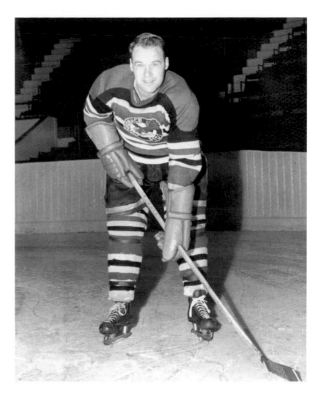

DANNY SUMMERS (DEFENSE). From 1948 to 1951 with the Reds, Summers garnered 53 points, 42 assists, and 87 PIM in 203 games. He was a member of Providence's championship team of 1948–1949. The defenseman skated for President's Cup–winning Winnipeg (WHL) in 1955–1956 and won back-to-back Turner Cups with St. Paul (1959–1960 and 1960–1961) of the International Hockey League (IHL). This IHL was a league formed in the Midwest that existed from 1945 to 2001.

PAT EGAN (DEFENSE/COACH). He tallied 103 points, 78 assists, and 388 PIM in 187 games with Providence from 1951 to 1955. Egan served as Reds player/coach from 1953 to 1955, leading his team to a 47-77-10 (.388) record. He later piloted Springfield to three consecutive Calder Cup championships (1960, 1961, and 1962). Egan was a veteran of 11 NHL seasons between 1939 and 1951 and produced 230 points and 153 assists in 554 games.

KEN SMITH (LEFT WING). He had 79 points, 52 assists, and 45 PIM in 104 games during three seasons with the Reds from 1951 to 1954. An NHL veteran from 1944 to 1951, the left-winger registered 171 points, 93 assists, and 49 PIM in 331 games. Smith also skated in the AHL with Hershey in several seasons between 1945 and 1957 and with Pittsburg from 1950 to 1952.

JACK STODDARD (RIGHT WING).
Stoddard was a member of the Reds'
1948–1949 Calder Cup–winning
team. The right-winger produced
268 points, 133 goals, and 126 PIM
in 338 games during six seasons
with Providence from 1947 to 1952
and in 1954–1955. He skated in two
NHL campaigns from 1951 to 1953,
notching 31 points, 16 goals, and
31 PIM in 80 games. Stoddard also
won a Calder Cup with Cleveland
in 1953–1954.

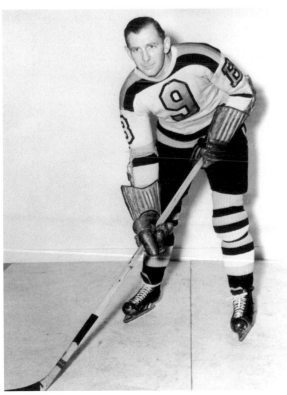

**IRVIN "YANK" BOYD (RIGHT
WING AND COACH).** He piloted
the Reds for two seasons from
1944 to 1946 and compiled a
46-64-12 (.426) record. As a player
with Providence from 1943 to
1945, the right-winger produced
34 points, 28 assists, and 12 PIM
in 39 games. A veteran of four
NHL campaigns between 1931
and 1944, Yank garnered 20
points, 10 goals, and 30 PIM in 96
games. He won a Sinclair Trophy
championship in 1939–1940 with
St. Paul (AHA).

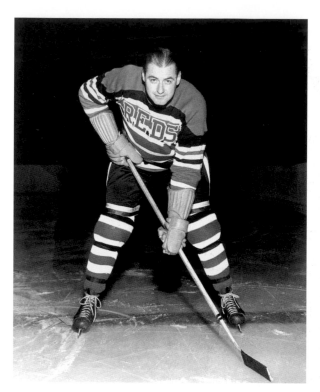

RAY POWELL (CENTER). Powell tallied 155 points and 103 assists in 126 games during two seasons with the Reds from 1951 to 1953. In the NHL in 1950–1951, the center had 22 points and 15 assists in 31 games. In 1951–1952, he became one of only two Reds players to win the AHL regular season MVP and AHL regular season leading scorer award in the same season (Carl Liscombe was the other player in 1947–1948).

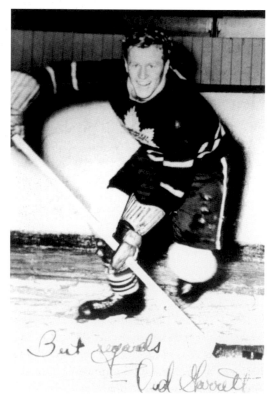

DUDLEY "RED" GARRETT (DEFENSE). The AHL's outstanding rookie award is named in his memory and has been given out since the 1947–1948 season. Garrett gave his life in World War II while serving in the Canadian Navy. In his only season of professional hockey in 1942–1943, Red played six games with Providence and 23 games with the New York Rangers (NHL). The defenseman had two points and one goal with the Rangers (NHL).

4

AN AFFILIATION WITH
THE RANGERS BRINGS A
FOURTH AHL TITLE

Providence had its first NHL affiliation in 10 seasons in 1955–1956 when they established a working agreement with the New York Rangers. The New York–Providence tie-up would last until the 1957–1958 season. The Rangers' farmhands during this era gave the Reds line-up the boost that it had lacked for several years. Jim Bartlett, Johnny Bower, Bruce Cline, Aldo Guidolin, Camille Henry, Marcel Paille, and Lorne "Gump" Worsley were among those Reds players assigned by the Rangers.

The effects of the new Rangers affiliation were felt immediately with a fourth Calder Cup title in 1955–1956. Providence had the best regular season record in the AHL that year (45-17-2), setting all-time team records for most wins in a season and best regular season record (.719) behind new coach Johnny Crawford. The Reds players stole the show when it came to AHL awards and all-stars that season. Johnny Bower was named AHL regular season MVP, Zellio Toppazzini won the AHL scoring title, and Bruce Cline was given the Dudley "Red" Garrett Memorial Award as the AHL's outstanding rookie. Johnny Bower, Camille Henry (left wing), and Zellio Toppazzini (right wing) were named first team all-stars, while Andy Branigan (defenseman) was named to the second all-star team. In the postseason, Providence beat the Buffalo Bisons three games to two in the semifinals and then swept Cleveland in four straight to win the Calder Cup.

Several all-time team records were set during that memorable 1955–1956 championship season. Zellio Toppazzini set the Reds' all-time record for assists in a single-season (71) and posted the second highest single-season point total (113) in Reds' history. Johnny Bower set the Reds' all-time record for most wins in a single-season (45). Camille Henry tied an AHL record by scoring six goals in a game on February 26, 1956, at home versus Springfield. Camille Henry's 50 goals that season made him one of only two players in Reds' history to accomplish that feat (Carl Liscombe scored 50 goals or more twice, in 1947–1948 [50] and in 1948–1949 [55]).

The Reds had the AHL's best regular season record once again in 1956–1957 going 34-22-8. First team all-star Johnny Bower was named AHL regular season MVP and received the AHL's Harry "Hap" Holmes Memorial Award as outstanding team goaltender. Paul Larivee tied for a first all-star team spot at center, and defenseman Ivan Irwin attained a second team all-star position. In the postseason, however, Providence lost in the semifinals against the Rochester Americans four games to one.

Providence hosted the AHL's third annual All-Star Game on October 23, 1956. The match was between the defending champion Reds and an all-star squad composed of players from the AHL's other five teams. Providence shut out the AHL All-Stars 4-0 in front of a crowd of 3,289 fans at the Rhode Island Auditorium (the largest crowd for an AHL All-Star game at the time). The contest remains the only shutout in AHL All-Star Game history. Goals were tallied by Jim Bartlett, Dusty Blair, Ray Cyr, and Camille Henry. It was the third year in a row that the AHL had this type of all-star game format, and the Reds were not only the first team to beat the league all-star squad but were the first to complete a "clean sweep" of all three league honors (also winning the AHL regular season and playoffs from the year before).

In 1957–1958, the locals finished in third place with a 33-32-5 mark. Bill Sweeney was selected as the AHL's outstanding rookie, and Ivan Irwin gained a first team all-star selection at defense. In the semifinal round of the playoffs, the Reds bowed to Hershey four games to one.

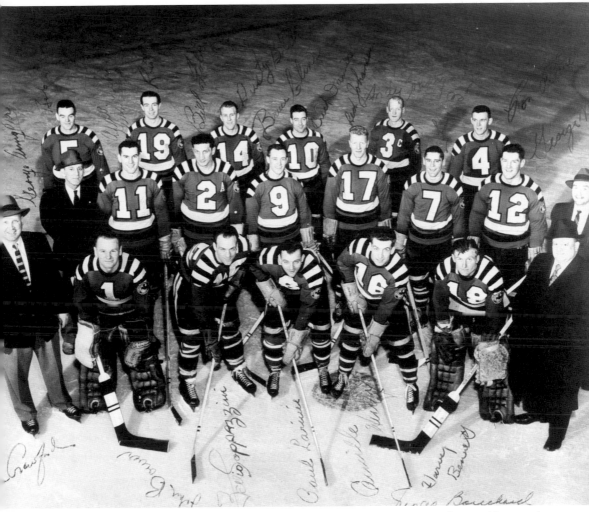

CALDER CUP CHAMPION REDS, 1955–1956. Pictured here from left to right are (first row) Jack Crawford (coach), Johnny Bower, Zellio Toppazzini, Paul Larivee, Camille Henry, Harvey Bennett, and Louis A. R. Pieri (president); (second row) George Army (trainer), Aldo Guidolin, Bill Folk, Bruce Cline, Bill Johansen, Jim Bartlett, George McAvoy, and Terry Reardon (general manager); (third row) Bob Robertson, Ray Ross, Dusty Blair, Kenneth Davies, Andy Branigan, and Ron Attwell.

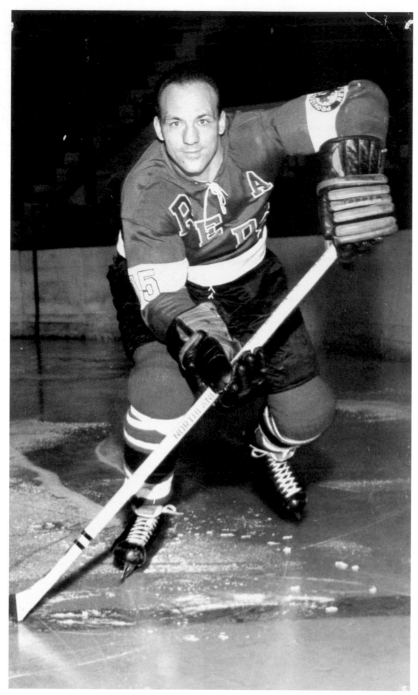

Zellio Toppazzini (Right Wing). "Topper" is the Reds' all-time leader in points (721), goals (277), assists (444), and games (683). He is one of three players to spend 12 seasons with Providence, skating with the Reds from 1951 to 1959 and from 1960 to 1964. Toppazzini led the AHL in scoring in 1955–1956. The right-winger ranks 12th in assists (476), 13th in points (786), and 16th in goals (310) in AHL history.

RAY ROSS (CENTER). In seven campaigns with the Reds from 1954 to 1961, Ross produced 219 points, 104 goals, and 71 PIM in 380 games. He won an AHL championship with Providence in 1955–1956 and also skated for back-to-back Calder Cup–winning Cleveland teams in 1952–1953 and 1953–1954. The center also played in the AHL with Pittsburg from 1961 to 1963.

JIM BARTLETT (LEFT WING). Bartlett is the Reds' all-time penalty minute leader with 705 PIM. He is third all-time in goals (200), fifth all-time in points (435), fifth all-time in games (512), and seventh all-time in assists (235) in Reds' history. Bartlett skated with Providence for eight seasons from 1955 to 1958 and from 1961 to 1966. He ranks 8th in goals (360), 9th in games played (955), and 19th in points (742) in AHL history.

JACK CRAWFORD (DEFENSE AND COACH). He guided Providence to a Calder Cup title in 1955–1956 and compiled a 178-143-19 (.551) record during five seasons as Reds coach from 1955 to 1960. In 1937–1938, he skated for the Reds and had 13 points in 46 games. Crawford spent 13 years in the NHL from 1937 to 1950, tallying 178 points in 548 games. He won two Stanley Cups with Boston in 1938–1939 and 1940–1941.

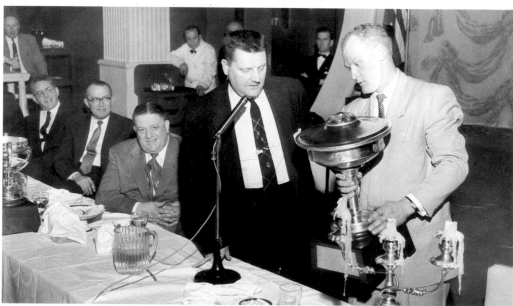

BRANIGAN RECEIVES TEDDY OKE TROPHY. AHL publicity director Jim Ellery (standing, left) presents Reds captain Andy Branigan (right) with the Teddy Oke Trophy for the Reds winning the AHL regular season title with an all-time best team record of 45-17-2 (.719). Seated to the left of Jim Ellery is Reds owner Louis A. R. Pieri. Providence also won the AHL playoff championship during the 1955–1956 season and was awarded the Calder Cup (located on the table).

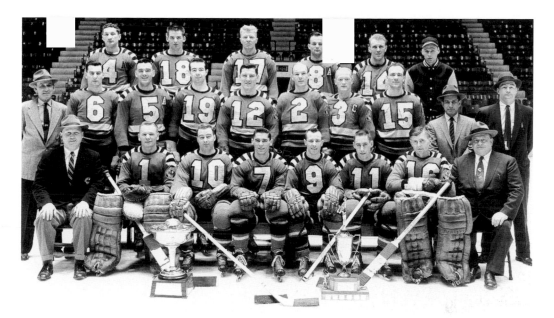

PROVIDENCE REDS, 1956–1957. Shown here from left to right are (first row) Jack Crawford (coach), Johnny Bower, Kenneth Davies, Jim Bartlett, Bruce Cline, Ray Cyr, Harvey Bennett, and Louis A. R. Pieri (owner); (second row) George Army (trainer), Aldo Guidolin, Bob Robertson, Ray Ross, George McAvoy, Ivan Irwin, Andy Branigan, Zellio Toppazzini, Johnny Gagnon, and Terry Reardon (general manager); (third row) Bill Folk, Robert Kabel, Bill Johansen, Paul Larivee, Dusty Blair, and Tom Woodcock (assistant trainer).

GEORGE ARMY (TRAINER). He has the longest tenure of any Reds personnel, serving as team trainer from 1934–1935 to 1968–1969. Army passed away on the job on January 11, 1969. He served in two AHL All-Star Games (1941–1942 and 1956–1957) and was with the Reds during all four of their Calder Cup championship seasons.

MARCEL PAILLE (GOALIE). He played more games in goal (765) than any other goaltender in AHL history. In eight seasons with Providence in 1957–1958 and from 1965 to 1972, the goaltender had a 3.66 GAA in 402 games. Paille won back-to-back AHL outstanding team goaltender awards in 1960–1961 and 1961–1962 and played for Springfield's three consecutive Calder Cup–winning teams in the early 1960s. He appeared in seven NHL seasons between 1957 and 1965.

CAMILLE HENRY (CENTER). A member of the Reds' 1955–1956 Calder Cup–winning team, the center produced 138 points and 81 goals in 88 games during two seasons with Providence from 1955 to 1957. A veteran of 14 NHL campaigns between 1953 and 1970, he tallied 528 points and 279 goals in 727 games. Henry won the NHL's rookie of the year award in 1953–1954 and the Lady Byng Memorial Trophy (most gentlemanly player) in 1957–1958.

ALDO GUIDOLIN (RIGHT WING/DEFENSE).
He was a member of the Reds' 1955–1956
championship team. Guidolin had 102
points, 79 assists, and 360 PIM in 215 games
during four seasons with Providence from
1955 to 1958 and in 1965–1966. In four
NHL campaigns from 1952 to 1956, he
garnered 24 points, 15 assists, and 117 PIM
in 182 games. He is 14th all-time in games
played in AHL history with 879.

ANDY BRANIGAN (DEFENSE).
He was a member of the Reds'
1955–1956 championship team. In
238 games with Providence from
1954 to 1958, the defenseman
notched 56 points, 45 assists, and
324 PIM. Branigan played in two
NHL seasons from 1940 to 1942 and
tallied three points and two assists
in 27 games. He is 15th all-time in
games played in AHL history with
859. Branigan also won a Calder
Cup with Hershey in 1946–1947.

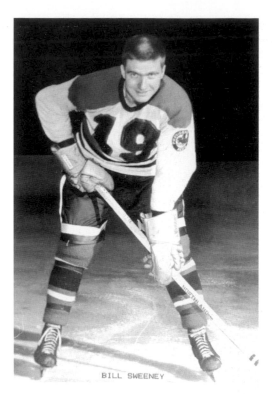

BILL SWEENEY

BILL SWEENEY (CENTER). In 1957–1958 with Providence, Sweeney had 77 points and 31 goals in 70 games, and he was named AHL outstanding rookie. The center ranks 8th all-time in assists (510) and 10th all-time in points (804) in AHL history. He earned three straight AHL scoring titles from 1960–1961 to 1962–1963 and won three straight Calder Cups with Springfield from 1959–1960 to 1961–1962.

KENNETH DAVIES (CENTER). He garnered 253 points, 176 assists, and 251 PIM in 399 games during eight years with Providence from 1949 to 1952 and from 1953 to 1958. Davies was a member of the 1955–1956 Calder Cup champion Reds. The center had a stint in the NHL during the Stanley Cup playoffs in 1947–1948.

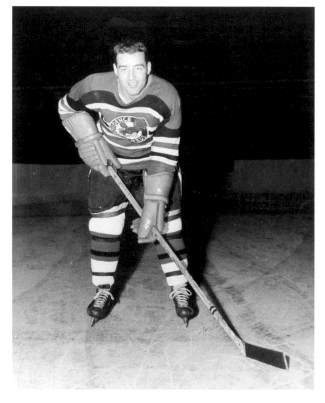

AN AFFILIATION WITH THE RANGERS

PAUL LARIVEE (CENTER). He is second all-time in points (539), goals (217), and assists (322), and third all-time in games (570) in Reds' history. Larivee also collected 278 PIM during the 10 seasons he skated with Providence from 1952 to 1962. The center was a member of the Reds' 1955–1956 Calder Cup–winning team.

GEORGE "BABE" McAVOY (DEFENSE). Babe was a member of the Reds' 1955–1956 championship team. The defenseman produced 65 points, 56 assists, and 317 PIM in 149 games during three seasons with Providence from 1955 to 1958. McAvoy also played in the AHL with Cleveland from 1958 to 1960 and spent four seasons in the WHL between 1958 and 1963.

BOB "KENNETH" ROBERTSON (DEFENSE). In five seasons with the Reds from 1954 to 1959, Robertson accumulated 501 PIM, 70 points, and 57 assists in 218 games. He was a member of Providence's 1955–1956 Calder Cup–winning team. The defenseman also skated in the AHL with Pittsburg in 1949–1950, Cleveland in 1958–1959, and Quebec in 1959–1960.

PROGRAM OF THE AHL's THIRD ANNUAL ALL-STAR GAME. Providence hosted the AHL's third annual All-Star game on October 23, 1956. The game was played between the defending Calder Cup champion Reds and an all-star team made up of players from the AHL's other five clubs. The Reds won the game by recording the only shutout in AHL All-Star Game history (4-0) behind the goaltending of Johnny Bower.

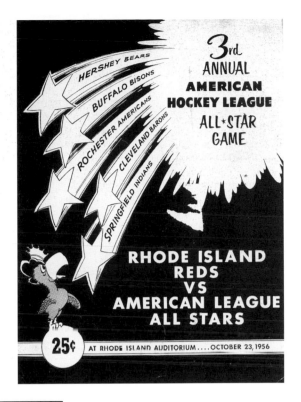

IVAN IRWIN (DEFENSE AND COACH). In three seasons with Providence from 1955 to 1958, Irwin accumulated 338 PIM, 41 points, and 35 assists in 144 games. The defenseman skated for the Reds' Calder Cup–winning team in 1955–1956. In 1965–1966, he coached Providence to a 20-49-3 record (.299). A veteran of five NHL campaigns between 1952 and 1958, Irwin had 29 points and 27 assists in 155 games.

BRUCE CLINE (RIGHT WING). Cline won the AHL's outstanding rookie award in 1955–1956 with Calder Cup champion Providence. In three seasons with the Reds from 1955 to 1958, the right-winger produced 151 points and 91 assists in 170 games. Cline ranks 12th in goals (321) and 15th in points (773), and he is tied for 15th in assists (452) in AHL history. He won three consecutive Calder Cups with Springfield in the early 1960s.

EDDIE SHACK (LEFT WING). He played his first pro season with Providence in 1957–1958 and notched 34 points, 16 goals, and 98 PIM in 35 games. A 17-year NHL veteran from 1958 to 1975, Shack amassed 1,437 PIM, 465 points, and 239 goals in 1,047 NHL games. He skated for all four Toronto Stanley Cup–winning teams in the 1960s.

The Boston Bruins

Reestablish Providence

as its Farm Team

The Reds secured a working agreement with the Boston Bruins prior to the 1958–1959 season. Providence was originally affiliated with Boston in the late 1930s. The new Bruin-Reds relationship lasted through the 1964–1965 campaign. Jean-Guy Gendron, Jeannot Gilbert, Larry Hillman, Matt Ravlich, and Ed Westfall donned a Reds jersey courtesy of Boston (NHL).

In 1958–1959, the locals finished in last place with a 28-40-2 record under coach Jack Crawford. In Jack Crawford's fifth and final season piloting the club in 1959–1960, the Reds bounced back to a third place finish and a 38-32-2 record. Individual honors went to Larry Hillman as the AHL's outstanding defenseman and a first team all-star and to Stan Baluik as the AHL's outstanding rookie. In the postseason, Providence lost to Springfield four games to one in the semifinals.

Phil Watson took over behind the bench in 1960–1961, but the club responded with a 26-46-0 record finishing in last place. Prior to the 1961–1962 campaign, the Reds named Fern Flaman player/coach. The new skipper guided Providence to a 36-32-2 record and a playoff berth with a third place divisional finish (the AHL had a two-division format from the 1961–1962 to the 1975–1976 season). The locals lost in the first round to Hershey, two games to one.

In 1962–1963, the club secured a first place finish for the first time in six seasons, winning their division with a 38-29-5 mark. Eddie Giacomin led the AHL with a 2.62 GAA. The Reds, however, were eliminated in the semifinal round against Western Division–winning Buffalo, four games to two.

During Fern Flaman's last two seasons piloting Providence, the team had sub-.500 records—32-35-5 in 1963–1964 with a third place divisional finish and 20-50-2 in 1964–1965, finishing in last place in its division. The Reds made the postseason in 1963–1964 but had an early exit against Hershey, two games to one.

The Reds did not have a formal affiliation with an NHL club from the 1965–1966 to the 1968–1969 season. This period of operating independently came after a decade of having working agreements with NHL teams. During the first two seasons without an NHL tie-up in 1965–1966 and 1966–1967, Providence finished in last place in its division and missed the postseason. In 1965–1966, former Reds player Ivan Irwin piloted the team to a 20-49-3 record. Dave Creighton was named player/coach in 1966–1967 and had a 13-46-13 mark.

In the summer of 1967, Louis A. R. Pieri, who had owned the Reds since the 1939–1940 season, passed away. Ownership of the team went to his estate and his son Louis Pieri Jr. operated the team in 1967–1968 and 1968–1969.

Dave Creighton turned in an AHL MVP performance during the regular season in 1967–1968 and guided the Reds to their first postseason appearance in four years with a third place divisional finish (30-33-9). Dave Creighton (named a second team all-star at center) and right-winger Ed Kachur (selected to the first all-star team) were the first Providence players to be named to the AHL All-Star team in eight seasons. The Reds won their first playoff series since the 1955–1956 Calder Cup finals by defeating the Springfield Kings three games to one in the first round of the postseason. In the semifinals, the locals lost to the Quebec Aces, three games to one.

In 1968–1969, the Reds made the playoffs once again with a third place divisional finish (32-36-6). Providence defeated the Baltimore Clippers in the opening round of the playoffs three games to one. It marked the first time that the Reds won the first round series of the Calder Cup playoffs in consecutive years since the 1948–1949 and 1949–1950 seasons. The locals were knocked out of the semifinal round against Quebec, three games to two.

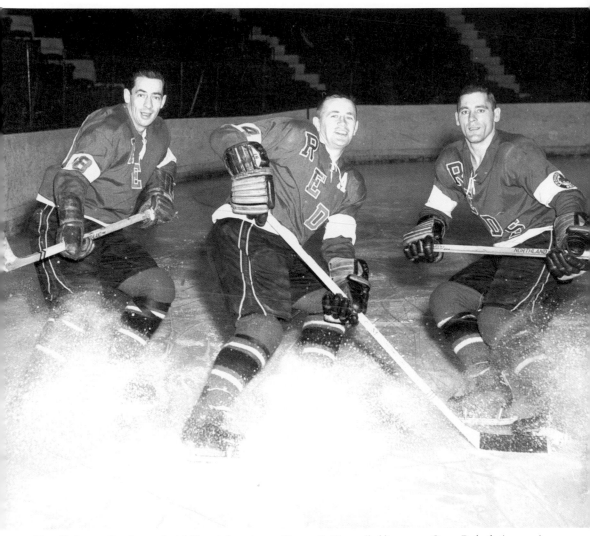

THE B-LINE. In the early 1960s, right-winger Pierre Brillant (left), center Stan Baluik (center), and left-winger Jim Bartlett (right) made up one of the AHL's most prolific and popular scoring lines nicknamed the "B-Line."

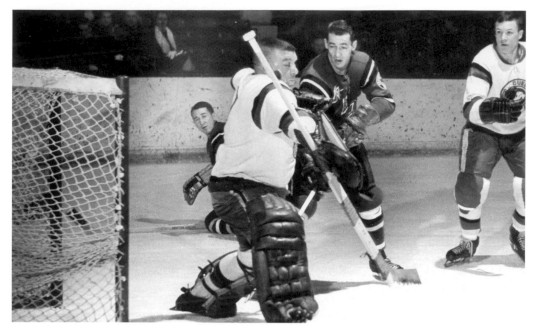

PIERRE BRILLANT (RIGHT WING). Brillant (standing in dark uniform) looks for a rebound against Quebec goalie Gump Worsley. Brillant is sixth in goals (165), ninth in points (332), and ninth in games (419) in Reds' history. The right-winger also has 167 assists and 76 PIM during eight years with Providence in 1954–1955 and from 1961 to 1968. He won a Turner Cup in 1957–1958 with Indianapolis (IHL).

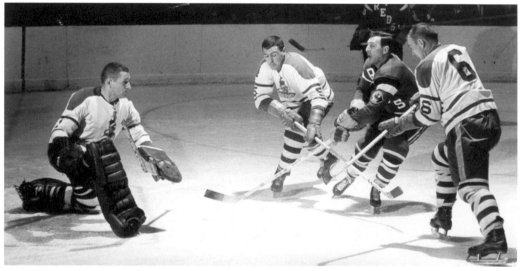

WILLIE MARSHALL (CENTER). Marshall (in the dark uniform) makes a shot on goal versus Cleveland. Marshall is the AHL's all-time leader in points (1,375), goals (523), assists (852), and games (1,205) and is one of only two players to appear in 20 seasons in the league. In the center's three years with the Reds from 1963 to 1966, he tallied 179 points and 121 assists in 211 games. Marshall skated with three Calder Cup–winning teams.

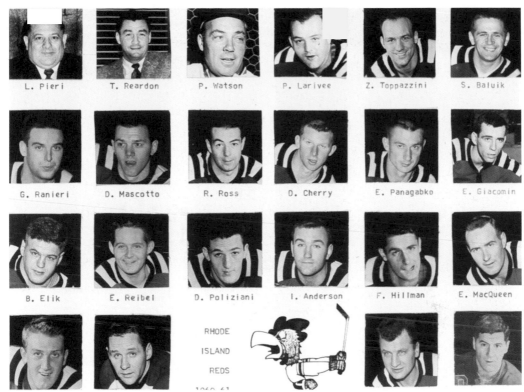

L. Pieri | T. Reardon | P. Watson | P. Larivee | Z. Toppazzini | S. Baluik

G. Ranieri | D. Mascotto | R. Ross | D. Cherry | E. Panagabko | E. Giacomin

B. Elik | E. Reibel | D. Poliziani | I. Anderson | F. Hillman | E. MacQueen

RHODE ISLAND REDS

PROVIDENCE REDS, 1960–1961. Pictured here from left to right are (first row) Bob Beckett, Fred Creighton, Benny Woit, and Bob Blackburn; (second row) Boris Elik, Earl Reibel, Dan Poliziani, Ian Anderson, Floyd Hillman, and Ed MacQueen; (third row) George Ranieri, Dino Mascotto, Ray Ross, Dick Cherry, Ed Panagabko, and Eddie Giacomin; (fourth row) Louis A. R. Pieri (owner), Terry Reardon (general manager), Phil Watson (coach), Paul Larivee, Zellio Toppazzini, and Stan Baluik

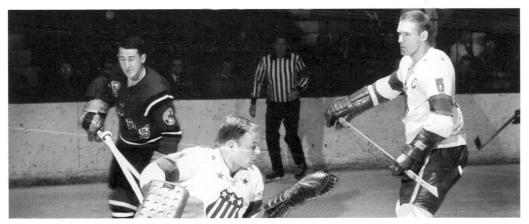

JEANNOT GILBERT (CENTER). Gilbert (in Reds uniform) skated to the net for a rebound, but Rochester goalie Gerry Cheevers makes the save. On the right of Gilbert is former Reds player Larry Hillman (No. 5). In 1964–1965 with Providence, Gilbert had 55 points and 25 goals in 64 games. Gilbert is tied for 22nd all-time in assists (419) and is 28th all-time in points (650) in AHL history.

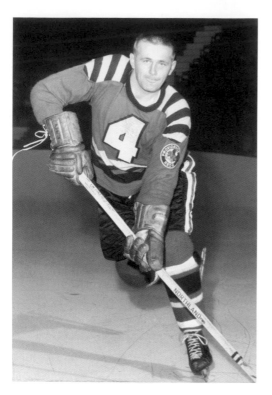

STAN BALUIK (CENTER). He ranks sixth all-time in assists (249) and eighth all-time in points (373) in Reds' history. Baluik also registered 124 goals and 289 PIM in 342 games during five seasons with Providence from 1959 to 1964. The center was named AHL outstanding rookie in 1959–1960. Baluik had a stint in the NHL in 1959–1960.

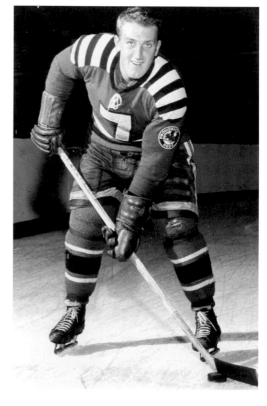

BOB BECKETT (CENTER). In six seasons with the Reds from 1958 to 1964, Beckett had 207 points, 77 goals, and 103 PIM in 283 games. In the NHL between 1956 and 1964, the center garnered 13 points, 7 goals, and 18 PIM in 68 games. He skated for O'Connell Trophy–winning Quebec (QHL) in 1956–1957.

ED MACQUEEN (DEFENSE). He is seventh all-time in games (462) in Reds' history. MacQueen registered 241 points, 168 assists, and 552 PIM during eight years with Providence from 1958 to 1966. He also skated in the AHL with Cleveland between 1954 and 1959 and Baltimore from 1965 to 1971. The defenseman was a member of President's Cup–winning Vancouver in 1957–1958.

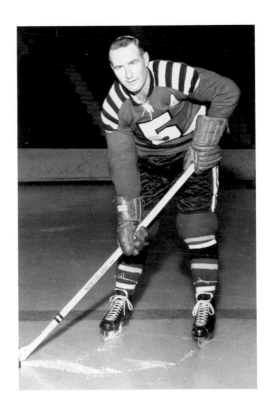

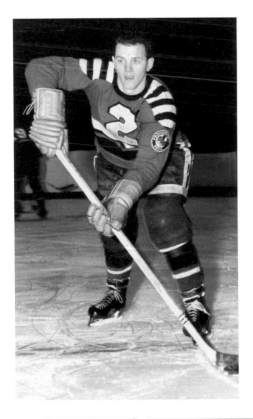

DINO MASCOTTO (DEFENSE). The defenseman notched 29 points, 23 assists, and 333 PIM in 200 games during four years with Providence in 1958–1959 and from 1960 to 1963. Mascotto also spent time in the QHL from 1956 to 1958, Eastern Professional Hockey League (EPHL) in 1959–1960, and IHL between 1968 and 1972.

GEORGE RANIERI (LEFT WING). In five seasons with the Reds from 1960 to 1965, Ranieri collected 244 points, 110 goals, and 196 PIM in 294 games. He had a stint in the NHL in 1956–1957. The left-winger won a Turner Cup with Louisville (IHL) in 1958–1959 and was the IHL's leading scorer that season. He also played in the AHL with Hershey from 1956 to 1958.

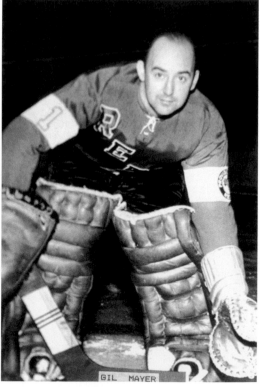

GIL MAYER (GOALIE). Mayer won the AHL's outstanding team goalie award five times (1950–1951, 1952–1953, 1953–1954, 1954–1955, and 1955–1956) while playing for Pittsburg. He was also between the pipes for four Calder Cup–winning teams (Pittsburgh in 1951–1952 and 1954–1955, and Hershey in 1957–1958 and 1958–1959). In two seasons with Providence from 1961 to 1963, he posted a 3.45 GAA and a 32-28-4 record in 64 games.

HARRY PIDHIRNY (CENTER). The center ranks third in games (1,071), sixth in goals (376), and seventh in points (829) in AHL history. In 1962–1963 with Providence, Pidhirny registered 35 points and 22 assists in 53 games. He won Calder Cups with Springfield in 1959–1960 and 1960–1961 and skated for Turner Cup–winning Muskegon (IHL) in 1967–1968.

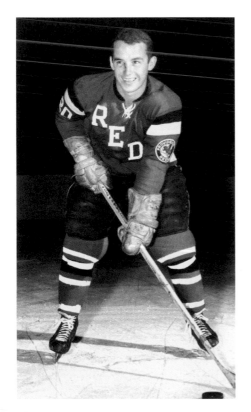

SERGE BOUDREAULT (LEFT WING). The left-winger tallied 144 points, 98 assists, and 228 PIM in 299 games during seven campaigns with the Reds from 1961 to 1968. He also skated in the AHL with Baltimore in 1962–1963 and Springfield in 1966–1967, and he spent time in the QHL in 1958–1959, Eastern Hockey League (EHL) from 1959 to 1961, and the IHL from 1967 to 1970.

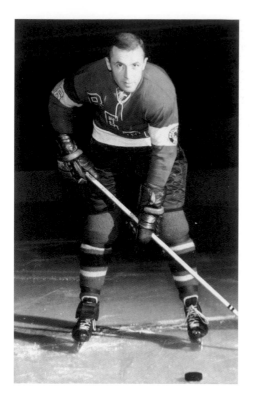

LARRY LEACH (CENTER). The center had 136 points, 82 assists, and 156 PIM in 174 games during four years with Providence in 1958–1959 and from 1961 to 1964. Leach spent most of his career in the WHL between 1955 and 1973, winning three Patrick Cups in 1960–1961, 1964–1965, and 1970–1971. In three NHL seasons between 1958 and 1962, he registered 42 points in 126 games.

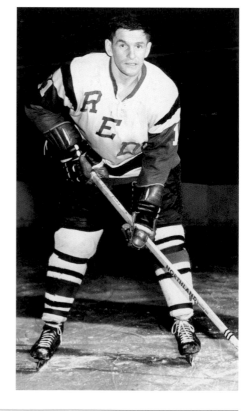

WAYNE MULOIN (DEFENSE). In five seasons with the Reds from 1965 to 1969 and 1976–1977, Muloin had 69 points, 58 assists, and 344 PIM in 303 games. The defenseman spent three years in the NHL between 1963 and 1971 and had 24 points, 21 assists, and 93 PIM in 147 games. He also skated in the WHA from 1972 to 1976, tallying 53 points, 43 assists, and 180 PIM in 258 games.

DAN POLIZIANI (RIGHT WING). The right-winger produced 244 points, 149 assists, and 255 PIM in 289 games during five years with Providence from 1958 to 1963. Poliziani also played in the AHL with Cleveland from 1954 to 1958 and Hershey from 1963 to 1965. He skated for Calder Cup–winning Cleveland in 1956–1957. Poliziani had a stint in the NHL in 1958–1959.

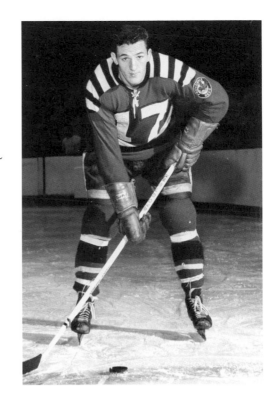

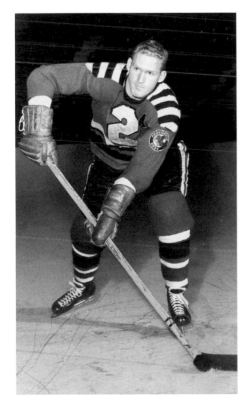

LARRY HILLMAN (DEFENSE). In his 19-year NHL career from 1954 to 1973, Hillman produced 232 points, 196 assists, and 579 PIM in 790 games. The defenseman skated for six Stanley Cup–winning teams (Detroit [1954–1955], Toronto [1961–1962, 1962–1963, 1963–1964, and 1966–1967], and Montreal [1968–1969]) and three Calder Cup–winning teams (Rochester 1964–1965, 1965–1966, and 1967–1968). In 1959–1960 with Providence, he produced 43 points, 31 assists, and 159 PIM in 70 games.

BUSTER CLEGG (GENERAL MANAGER). He was general manager of the Reds from 1966 to 1968. Clegg originally joined Providence for the 1959–1960 campaign and held several front office assignments prior to being appointed general manager. As general manager, he acquired players like Keller, Locas, Mantha, McKenney, Meissner, Sleaver, and White. In 2001, he was the catalyst in the formation of the Rhode Island Reds Heritage Society, which he now serves as founding president.

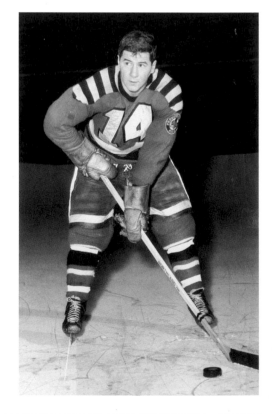

BOB BLACKBURN (DEFENSE). The defenseman amassed 663 PIM, 73 points, and 66 assists in 362 games during seven seasons with Providence from 1959 to 1966. He won the AHL's outstanding defenseman award in 1968–1969. In the NHL from 1968 to 1971, Blackburn garnered 105 PIM, 20 points, and 12 assists in 135 games.

BENNY WOIT (RIGHT WING/DEFENSE).
In two campaigns with the Reds from 1959
to 1961, he had 15 points and 12 assists in
88 games. A veteran of seven NHL seasons
from 1950 to 1957, Woit had 33 points and 26
assists in 334 games. He won three Stanley
Cups with Detroit in 1951–1952, 1953–1954,
and 1954–1955. Woit also won a Calder Cup
with Indianapolis in 1949–1950 and a Walker
Cup with Clinton (EHL) in 1963–1964.

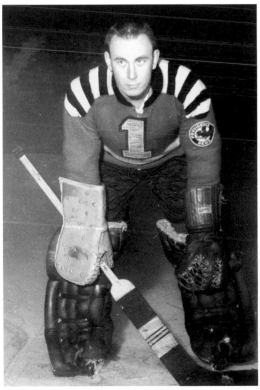

BRUCE GAMBLE (GOALIE). Gamble earned
a 3.47 GAA and a 44-45-2 record in 91
games during three years with the Reds in
1957–1958 and from 1959 to 1961. A veteran
of 10 NHL seasons between 1958 and 1972,
the goaltender earned a 3.21 GAA and a
110-150-46 record in 327 games. He set the
Reds' single-season record for games in goal
(71) in 1959–1960. Gamble played for Stanley
Cup–winning Toronto in 1966–1967.

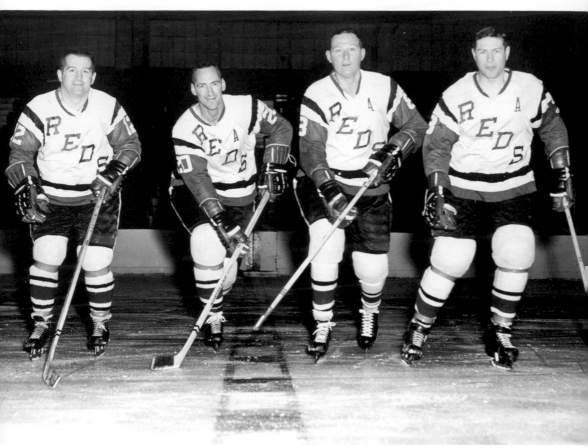

REDS STARS OF THE LATE 1960S. From left to right are right-winger Ed Kachur, who played with Providence from 1964 to 1970; defenseman Moe Mantha, who played with Providence from 1967 to 1969; center John Sleaver, who played with Providence from 1966 to 1969; and defenseman Adam Keller, who played with Providence from 1966 to 1971.

THE BOSTON BRUINS REESTABLISH PROVIDENCE

THE REDS' LATER
AHL SEASONS

George M. Sage purchased the Reds from Louis Pieri Jr. prior to the 1969–1970 season. The Oakland Seals formed a working agreement with Providence for 1969–1970, which would be Dave Creighton's last season as coach. It was the Reds' first NHL affiliation in five seasons. Despite the NHL tie-up, the locals finished in last place in their division with a 23-36-13 record.

In the second season of the NHL Seals affiliation (now called the California Golden Seals) in 1970–1971, the Reds became the first team in AHL history to win a division title with a losing regular season record (28-31-13). It was the team's first division title since 1962–1963. New coach Larry Wilson led his team to a semifinal series upset against Western Division–winning Baltimore, four games to two. In the only Calder Cup finals series that involved two teams with losing regular season records, Providence was swept by Springfield in four games.

From 1971–1972 to 1974–1975, the Reds were solely affiliated with the New York Rangers. Larry Wilson remained as coach in 1971–1972, and center Don Blackburn led the AHL in scoring that season and was named to the second team all-stars. Providence finished in fourth in its division with a 28-37-11 record and lost in the first round of the playoffs to the Boston Braves four games to one.

In 1972–1973, the Reds moved out of the Rhode Island Auditorium and into the new 11,000-seat Providence Civic Center. Larry Popein was named coach prior to the 1972–1973 campaign and piloted the club to their first winning season since 1962–1963 with a 32-30-14 record and a fourth place divisional finish. The locals were swept in the opening round against the Nova Scotia Voyageurs in four games.

In 1973–1974, Providence made it all the way to the Calder Cup finals under new coach John Muckler. The Reds had a 38-26-12 regular season record with a second place finish in their division. Rick Middleton was named AHL outstanding rookie and was named a first team all-star at right wing. John Bednarski, who set the Reds' all-time single-season PIM mark (222) that season, was chosen as a second team all-star defenseman. In the playoffs, the locals beat Nova Scotia in the first round four games to two, and swept the New Haven Nighthawks in four straight in the semifinals before losing in the finals against Hershey, four games to one.

John Muckler was named AHL coach of the year in 1974–1975 after guiding the Reds to the AHL regular season title (the team's first since 1956–1957) with a 43-21-12 record. Left-winger Jerry Holland was named AHL outstanding rookie and Joe Zanussi was named AHL

outstanding defenseman. Jerry Holland and Joe Zanussi were also selected first team all-stars along with right-winger Pierre Laganiere. Right-winger Hartland Monahan was named to the second all-star team. In the playoffs, the Reds were stopped in the first round by the Springfield Indians four games to two.

In 1975–1976, Providence had a split NHL affiliation between the New York Rangers and the St. Louis Blues. The club finished in third place in its division with a 34-34-8 record. Greg Holst shared AHL outstanding rookie honors, and defenseman Al Simmons was named a second team all-star. In the postseason, the Reds were swept by Rochester in the first round in three games.

The team name was officially changed to the Rhode Island Reds for the 1976–1977 season under new owners Thomas O'Halloran and Robert Tiernan who were leasing the club from George M. Sage. The Reds also switched affiliations to the NHL's Colorado Rockies and the New England Whalers of the WHA. Rhode Island finished in last place in the AHL's six-team single-division format with a 25-51-4 record and failed to make the postseason for the first time in seven seasons. John Muckler was replaced midseason by former Reds player Ross Brooks. One bright spot was left-winger Walt Ledingham's selection to the first team all-stars.

There was a significant loss of revenue after the 1976–1977 campaign, and as a result, Thomas O'Halloran and Robert Tiernan broke their lease agreement with George M. Sage. In 1976–1977, the Reds experienced their worst attendance in nearly 10 seasons, and the escalating salaries brought on by the WHA made the situation even worse. With the financially ailing franchise entirely back on his shoulders, George M. Sage had no interest in further financing the Reds and sold the team. The club relocated to Binghamton, New York, and was renamed the Binghamton Dusters.

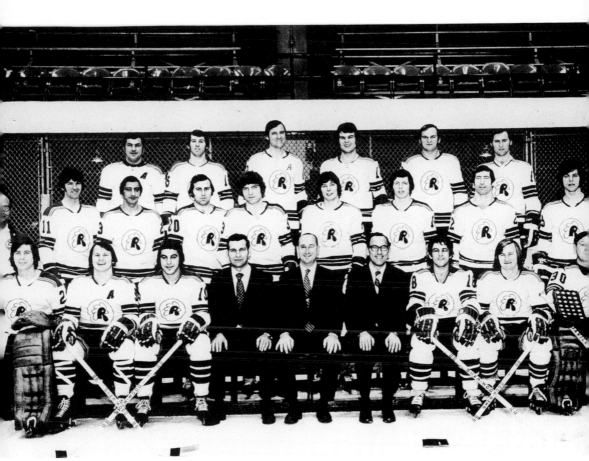

PROVIDENCE REDS, 1972–1973. Pictured here from left to right are (first row) Wayne Wood, Bill Heindl, Andre Peloffy, Larry Popein (general manager/coach), George M. Sage (owner), Thomas D. Pucci (vice president), Bob LePage, Ron Garwasiuk, and Rick Charron; (second row) Robert Batley (trainer), Gerry Teeple, Claude Houde, Al Blanchard, Larry Sacharuk, Jerry Butler, Bert Wilson, Nick Polano, and Rene Villemure; (third row) Dick Mattiussi, Doug Keeler, Billy Knibbs, Gary Coalter, Steve Andrascik, and Doug Horbul.

RICK MIDDLETON (RIGHT WING). In 14 NHL campaigns from 1974 to 1988, Middleton had 988 points, 448 goals, and 157 PIM in 1,005 games. He was the Rangers' number one draft pick (No. 14 overall) of the 1973 NHL Entry Draft and won the NHL's most gentlemanly player award in 1981–1982. In 1973–1974 with the Reds, the right-winger had 84 points and 36 goals in 63 games, and was named AHL outstanding rookie.

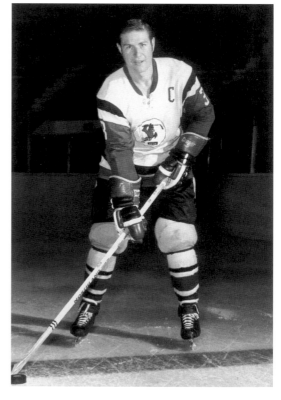

ADAM KELLER (DEFENSE). In five seasons with Providence from 1966 to 1971, Keller notched 190 points, 154 assists, and 488 PIM in 337 games. The defenseman also played in the AHL with Pittsburg from 1963 to 1965, and he spent time in the EPHL from 1960 to 1962 and the WHL for several seasons between 1959 and 1974. Keller was a member of Phoenix's (WHL) back-to-back Patrick Cup championship teams in 1972–1973 and 1973–1974.

THE REDS' LATER AHL SEASONS

Ross Brooks (Goalie/Coach/General Manager). Brooks was between the pipes for nine seasons with Providence in 1960–1961 and from 1963 to 1971, earning a 4.50 GAA in 128 games. In three NHL campaigns from 1972 to 1975, the goaltender compiled a 2.64 GAA and a 37-7-6 record in 54 games. In 1976–1977, Brooks replaced John Muckler as general manager/coach of the Reds and compiled a 4-21-2 (.185) record. He shared the AHL's outstanding team goaltender award in 1971–1972.

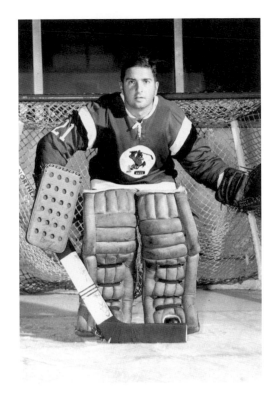

Dave Maloney (Defense). In his 11 NHL seasons from 1974 to 1985, Maloney tallied 317 points, 246 assists, and 1,154 PIM in 657 games. The defenseman played two seasons with the Reds from 1974 to 1976, garnering 55 points, 45 assists, and 203 PIM in 84 games. He was the Rangers' (NHL) number one draft pick (No. 14 overall) of the 1974 NHL Entry Draft.

DON MCKENNEY (CENTER). In 13 years in the NHL between 1954 and 1968, the center produced 582 points, 237 goals, and 211 PIM in 798 games. In two seasons with the Reds from 1968 to 1970, McKenney had 89 points, 60 assists, and 14 PIM in 105 games. He played with Calder Cup–winning Pittsburg in 1966–1967 and was named the NHL's most gentlemanly player in 1959–1960.

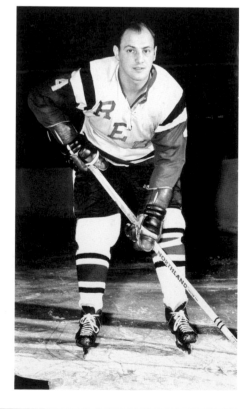

TONY GOEGAN (FORWARD). Goegan accumulated 174 points, 102 assists, and 337 PIM in 330 games during six years with Providence from 1964 to 1970. The forward also skated in the AHL with Baltimore between 1970 and 1973 and spent time in the EHL in 1964–1965.

BRIAN PERRY (CENTER). In five seasons with
the Reds (from 1965 to 1968, 1969–1970, and
1971–1972), Perry accumulated 202 points and
111 assists in 241 games. A veteran of three NHL
campaigns from 1968 to 1971, the center tallied 45
points and 16 goals in 96 games. He also skated in
three WHA seasons from 1972 to 1975 and had
64 points and 33 goals in 145 games.

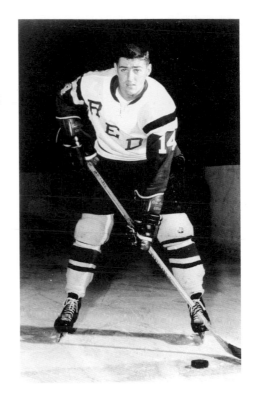

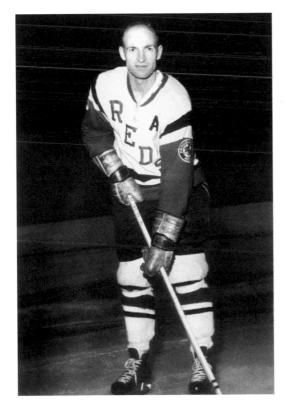

DAVE CREIGHTON (CENTER/COACH/
GENERAL MANAGER). Piloting the Reds from
1966 to 1970, Creighton was player/coach of
the team for three of those seasons (from 1966
to 1969). Creighton's coaching record with
Providence was 98-151-41 (.409). As a player
with the Reds from 1965 to 1969, the center
registered 223 points and 152 assists in 272
games. A veteran of 12 NHL campaigns from
1948 to 1960, Creighton garnered 314 points
and 140 goals in 616 games.

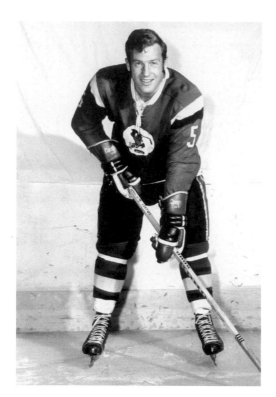

RAY CLEARWATER (DEFENSE). The defenseman produced 153 points, 117 assists, and 351 PIM in 341 games during six seasons with the Reds from 1966 to 1972. He skated in four WHA campaigns between 1972 and 1977 and tallied 104 points, 77 assists, and 141 PIM in 214 games. He also played in the AHL with Baltimore in 1975–1976 and New Haven from 1977 to 1980.

GEORGE PATRICK DUFFY (BROADCASTER AND TEAM PUBLICIST). He broadcasted Reds games from 1955 to 1973 and became known as the Voice of the Reds. Duffy also served as team publicist from 1945 to 1959 and was publicist for the Rhode Island Auditorium and all of its events. He is a member of the Rhode Island Reds Heritage Society's board of directors.

THE REDS' LATER AHL SEASONS

WAYNE WOOD (GOALIE). He posted a 3.04 GAA in 71 games with the Reds from 1971 to 1974. A veteran of five WHA seasons from 1974 to 1979, Wood compiled a 3.97 GAA and a 27-39-4 record in 104 games. He also played in the AHL with Adirondack from 1979 to 1981, spent several seasons in the Central Hockey League (CHL) between 1971 and 1980, and skated in the Pacific Hockey League (PHL) in 1978–1979.

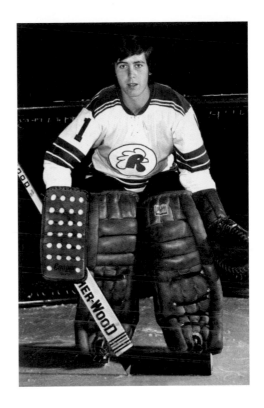

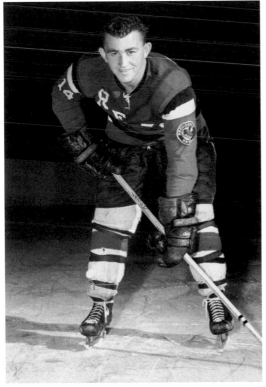

BOB LEDUC (FORWARD). Leduc is sixth all-time in games (496) in Reds' history. The forward produced 314 points, 129 goals, and 429 PIM during eight seasons with Providence from 1964 to 1972. He skated in the WHA for three campaigns from 1972 to 1975, notching 113 points, 47 goals, and 109 PIM in 158 games. Leduc also spent time in the North American Hockey League (NAHL) from 1975 to 1977.

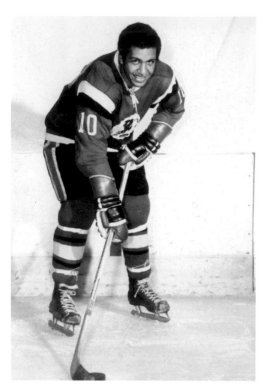

ALTON WHITE (RIGHT WING). White had 174 points, 84 goals, and 59 PIM in 218 games from 1968 to 1972 with the Reds. He skated in three WHA seasons from 1972 to 1975, tallying 84 points, 38 goals, and 45 PIM in 145 games. White is the only African-American to play for the Reds. Besides the AHL, the right-winger spent time in several other minor professional hockey leagues.

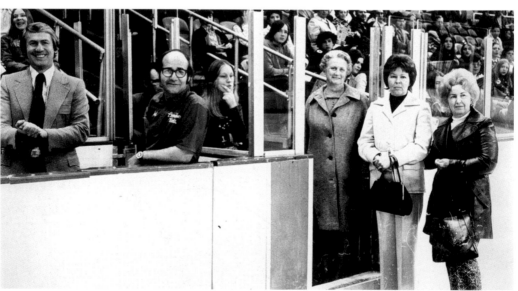

JOHN MUCKLER (COACH/GENERAL MANAGER). He piloted the Reds from 1973 to 1977, earning a 136-111-34 (.544) record. Muckler (far left) won the AHL's coach of the year award in 1974–1975. Muckler coached in the NHL between 1968 and 2000, compiling a 276-288-84 (.491) NHL record and winning a Stanley Cup with Edmonton in 1989–1990. He also guided Long Island (EHL) to a Walker Cup championship in 1964–1965 and Dallas (CHL) to an Adams Cup championship in 1978–1979.

Ron Stackhouse (Defense). In 1969–1970 with Providence, the defenseman had 37 PIM, six points, and five assists in 65 games. A veteran of 12 NHL seasons from 1970 to 1982, Stackhouse tallied 459 points, 372 assists, and 824 PIM in 889 games.

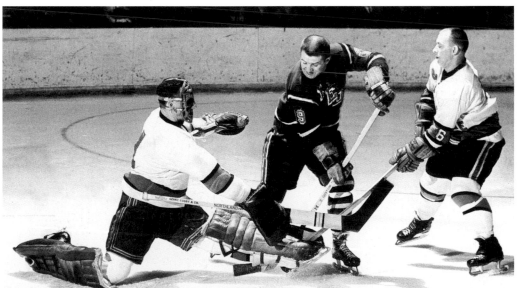

Ed Kachur (Right Wing). Kachur (in Reds uniform) attempts to score on Baltimore. Kachur ranks seventh all-time in goals (148) in Reds' history. He also registered 253 points, 105 assists, and 122 PIM in 317 games during six seasons with Providence from 1964 to 1970. In two NHL campaigns from 1956 to 1958, the right-winger produced 24 points and 10 goals in 96 games. Kachur won a Calder Cup with Buffalo in 1962–1963.

THE REDS 1975–1976 PROGRAM. The Reds became the first team in minor league hockey history to celebrate their 50th season. During the 1975–1976 campaign, Providence was only one of five professional hockey teams based in the United States that had operated for 50 continuous seasons. The Boston Bruins, founded in 1924–1925, were the only professional hockey team in the United States that had a longer tenure than the Reds in 1975–1976.

THE REDS' LATER AHL SEASONS

PROFESSIONAL HOCKEY
RETURNS TO PROVIDENCE

Professional hockey returned to Providence in 1992–1993 after the Maine Mariners, the Boston Bruins' (NHL) American Hockey League affiliate, moved to the Rhode Island capital. The team was renamed the Providence Bruins because the Boston (NHL) affiliation was retained and due to the strong Bruin (NHL) fan base in the area. The AHL had grown from a six-team, single-division league during the Reds last season in 1976–1977 to a 16-team, three-division circuit in 1992–1993. Mike O'Connell was named coach of the "P-Bruins," a nickname that the team was dubbed, and the club was based at the Providence Civic Center. The P-Bruins were a success on the ice and at the gate during their first season, winning their division with a 46-32-2 record and leading the AHL in average attendance. Tim Sweeney's 41 goals that season is still a team single-season record. Tim Sweeney was selected a second team all-star at left wing. In the postseason, Providence was upset in the first round against the Springfield Indians, four games to two. Mike O'Connell's team did not experience that much success in its second season in 1993–1994, finishing in last place with a 28-39-13 record and out of the playoffs.

In 1994–1995, Steve Kasper took the coaching reigns and guided Providence to a third place 39-30-11 finish and a berth in the playoffs. Jeff Serowik was awarded the AHL's outstanding defenseman award and was named a first team all-star. The P-Bruins won their first postseason series against the defending Calder Cup champion Portland Pirates four games to three. In the second round, the locals lost against the eventual Calder Cup champion Albany River Rats, four games to two.

The AHL held its first All-Star Game in 35 seasons in Providence on January 17, 1995. The Canadian All-Star team defeated the United States All-Star team 6-4 in front of a sellout crowd of 11,909 at the Providence Civic Center.

Steve Kasper was promoted to Boston (NHL) prior to the 1995–1996 campaign, and Bob Francis was named his replacement. The P-Bruins led the AHL in average attendance for the fourth season in a row in 1995–1996. On the ice, Providence earned a 30-40-10 record, finishing in fourth place, which was good enough for a playoff spot. The trail to the Calder Cup was short-lived with a first round elimination against the Springfield Falcons, three games to one.

In 1996–1997, Bob Francis's team again qualified for the postseason with a 35-42-3 record and a fourth place finish. Providence won its opening round playoff series over the Worcester IceCats, three games to two, but was stopped in the conference semifinal round against Springfield, four games to one.

The P-Bruins suffered their worst season in 1997–1998 with a 19-54-7 record and a last place finish. New coach Tom McVie did his best with a roster one-third full of AHL rookies.

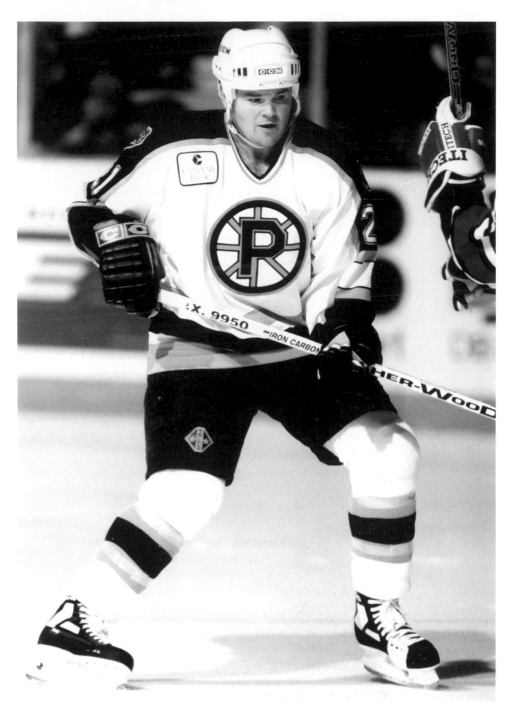

TIM SWEENEY (LEFT WING). Sweeney is fourth all-time in points (172) and tied for fourth all-time in goals (71) in P-Bruins' history. The left-winger registered 101 assists and 50 PIM in 121 games with Providence (1992–1993, from 1994 to 1997, and 1998–1999). From 1990 to 1998 in the NHL, he registered 138 points, 55 goals, and 123 PIM in 291 games. Sweeney set the P-Bruins' single-season goal mark with 41 in 1992–1993.

BILL ARMSTRONG (DEFENSE AND COACH).
He skated with Providence for five seasons,
from 1993 to 1995 and from 1996 to 1999,
accumulating 688 PIM, 26 points, and 22 assists
in 223 games. The defenseman was a member of
the P-Bruins' 1998–1999 Calder Cup–winning
team. Armstrong coached Providence from 2000
to 2002, compiling a 70-72-18 (.519—including
eight points from overtime losses) record. He
served as assistant coach of the P-Bruins from
1998 to 2000.

JON ROHLOFF (DEFENSE). In four seasons with the P-Bruins from 1993 to 1995 and 1996 to 1998, Rohloff had 63 points, 42 assists, and 111 PIM in 120 games. In the NHL from 1994 to 1997, the defenseman notched 32 points, 25 assists, and 129 PIM in 150 games. He also skated in the AHL with Kentucky in 1998–1999 and spent time in the IHL from 1998 to 2001.

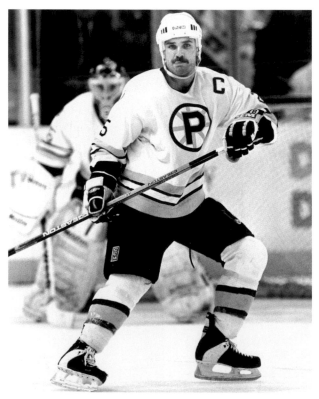

JAMIE HUSCROFT (DEFENSE). Huscroft is a veteran of 10 NHL seasons between 1988 and 2000 and amassed 1,065 PIM, 38 points, and 33 assists in 352 games. In two years with the P-Bruins from 1992 to 1994, the defenseman accumulated 414 PIM, 28 points, and 25 assists in 101 games. He also skated in the AHL with Utica from 1987 to 1992 and Portland from 1999 to 2001.

CAM STEWART (LEFT WING). In four campaigns with the P-Bruins from 1993 to 1997, the left-winger totaled 78 points, 37 goals, and 119 PIM in 117 games. In the NHL between 1993 and 2001, Stewart notched 39 points, 16 goals, and 120 PIM in 202 games. He spent time in the IHL from 1996 to 1999 and was a member of Turner Cup–winning Houston (IHL) in 1998–1999.

SERGEI ZHOLTOK (CENTER). The center ranks second all-time in points (186) and second all-time in goals (83), and he is tied for third all-time in assists (103) in P-Bruins' history. He also had 115 PIM in 196 games from 1992 to 1995 with Providence. In 10 NHL seasons between 1992 and 2004, Zholtok produced 258 points, 111 goals, and 166 PIM in 588 games.

DENIS CHERVYAKOV (DEFENSE). In four seasons with the P-Bruins from 1992 to 1996, the defenseman amassed 415 PIM, 63 points, and 53 assists in 235 games. Chervyakov had a stint in the NHL in 1992–1993. He also skated in the AHL with Kentucky in 1996–1997 and Portland in 1998–1999, the IHL between 1992 and 1999, and the East Coast Hockey League (ECHL) between 1998 and 2001.

MIKE BALES (GOALIE). He earned a 4.31 GAA and a 31-32-4 record in 77 games during two seasons with Providence from 1992 to 1994. A veteran of four NHL campaigns between 1992 and 1997, Bales compiled a 4.13 GAA and a 2-15-1 record in 23 games. The goaltender also played in the AHL with Port Edward Island from 1994 to 1996, Baltimore in 1996–1997, and Rochester in 1997–1998.

Grigori Panteleev (Left Wing).
He ranks tied for ninth all-time in points (140) in P-Bruins' history. The left-winger also tallied 61 goals and 78 PIM in 164 games during three campaigns with Providence from 1992 to 1995. In four NHL seasons from 1992 to 1996, Panteleev registered 14 points, 8 goals, and 12 PIM in 54 games. He skated for Turner Cup–winning Utah (IHL) in 1995–1996.

Rob Tallas (Goalie). The goaltender earned a 3.46 GAA and a 23-38-9 record in 73 games with the P-Bruins from 1994 to 1998. Tallas spent six seasons in the NHL from 1995 to 2001, compiling a 2.91 GAA and a 28-42-10 record in 99 games. He also played in the AHL with Norfolk in 2000–2001 and Wilkes Barre/Scranton from 2001 to 2003, and he spent time in the ECHL in 1994–1995 and the IHL in 2000–2001.

ANDRE ROY (LEFT WING). He accumulated 555 PIM, 57 points, and 30 assists in 144 games during three campaigns with Providence from 1995 to 1998. The left-winger spent eight seasons in the NHL between 1995 and 2006, amassing 850 PIM, 55 points, and 27 goals in 352 games. He was a member of Stanley Cup–winning Tampa Bay in 2003–2004.

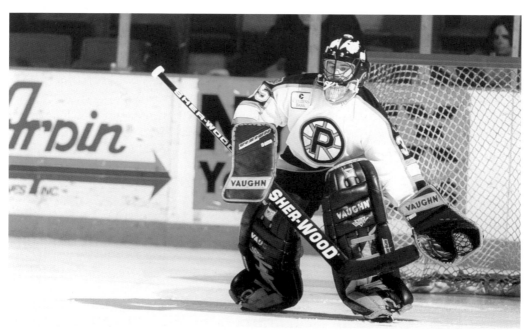

SCOTT BAILEY (GOALIE). Bailey ranks second all-time in games between the pipes (127) and is tied for third all-time in wins (53) in P-Bruins' history. He compiled a 53-54-16 record and a 3.33 GAA during four seasons with Providence from 1993 to 1997. In two NHL campaigns from 1995 to 1997, the goaltender earned a 3.42 GAA and a 6-6-2 record in 19 games.

8

THE P-BRUINS CAPTURE
THE CALDER CUP

The P-Bruins brought the city of Providence its fifth Calder Cup championship in 1998–1999. The club was loaded with AHL All-Stars and award winners and was piloted by former P-Bruin Peter Laviolette, who won AHL coach of the year honors. The team's 56-20-4 record earned them the AHL regular season crown and a second division title, setting all-time team records for wins in a season and points in the standings with 120 (includes four points from overtime losses). First team all-star center Randy Robitaille was named AHL regular season MVP, setting all-time team single-season marks for points (102) and assists (74). Brandon Smith (defenseman) and Landon Wilson (left wing) were also selected to the first team all-stars, while Terry Virtue (defenseman) was named a second team all-star. Andre Savage was named to the all-rookie team as a forward. In net, John Grahame set an all-time team single-season record for wins with 37. The P-Bruins went 15-4 in the postseason en route to the Calder Cup championship. The locals beat Worcester three games to one in the first round, swept the Hartford Wolf Pack in four in the next round, defeated the Fredericton Canadiens four games to two in the conference finals, and then downed the Rochester Americans in the Calder Cup finals four games to one. Peter Ferraro was named AHL playoff MVP.

Providence's chances for a repeat appeared to be slim during the 1999–2000 regular season, as the team had a 33-41-6 record, finished in last place in its division, and secured the final playoff spot (eight of nine teams in the conference made the postseason). But it was in the playoffs that Calder Cup fever caught on. Peter Laviolette's team swept its opponents during the first two playoff rounds—beating the Quebec Citadels in three straight and then the Lowell Lock Monsters in four straight to advance to the conference finals. In the conference finals, the P-Bruins took AHL regular season champion Hartford to the brink of elimination and came within one game of the Calder Cup finals, losing the series in seven games.

In 2000–2001, Bill Armstrong, a former Providence player who was the club's assistant coach for the past two seasons, was elevated to head coach. A mediocre record of 35-35-10 and a third place finish did not make for high expectations in the quest for the Calder Cup, but it was in the "second season" that the P-Bruins came alive again. This time, Providence won its first two playoff rounds in the maximum number of games, edging out Hartford in the best of five and then squeezing past Worcester in seven games. Providence made the AHL's "final four" of the playoffs for the third year in a row and was the only team to do so during those three seasons. In the conference finals, the eventual Calder Cup champion Saint John Flames defeated the locals four games to one. Kent Hulst received the AHL's Fred T. Hunt Memorial Award for sportsmanship, determination, and dedication to hockey.

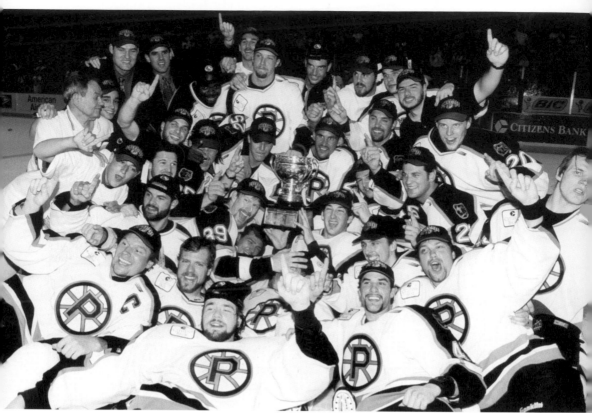

THE 1998–1999 CALDER CUP CHAMPIONS. The Providence Bruins celebrate after winning the 1998–1999 Calder Cup championship. With the P-Bruins Calder Cup title that season, the city of Providence became one of only two cities in AHL history to have two different teams win a Calder Cup championship. Portland, Maine, became the first city to have two different teams win Calder cup titles. The Maine Mariners (based in Portland, Maine) won three Calder Cups during their history and the Portland Pirates captured one Calder Cup crown in 1993–1994.

CAMERON MANN SKATES WITH THE CALDER CUP. Mann is third all-time in goals (73) and fifth all-time in points (159) in P-Bruins' history. The right-winger also totaled 86 assists and 268 PIM in 182 games from 1997 to 2001. He was a member of Providence's 1998–1999 championship team. A veteran of five NHL seasons between 1997 and 2003, Mann had 24 points, 14 goals, and 40 PIM in 93 games.

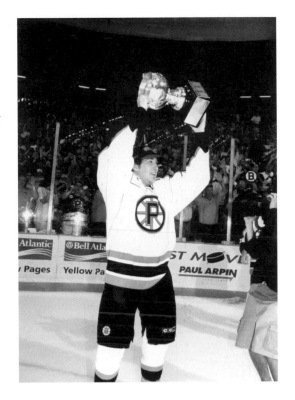

PETER FERRARO (LEFT WING). He was named AHL playoff MVP when Providence captured the Calder Cup in 1998–1999. Ferraro is ranked eighth all-time in points (142) in P-Bruins' history. The left-winger also had 62 goals and 221 PIM from 1998 to 2001 with Providence. In six NHL seasons between 1995 and 2002, Ferraro produced 24 points, 15 assists, and 58 PIM in 92 games.

PETER LAVIOLETTE (DEFENSE AND COACH).
Laviolette guided the P-Bruins to a Calder Cup and was named the AHL's coach of the year in 1998–1999. He piloted Providence to an 89-61-10 (.609—including seven points from overtime losses) record from 1998 to 2000. Prior to coaching the P-Bruins, he skated with the club for four seasons (1992–1993 and from 1994 to 1997) and had 125 points, 90 assists, and 241 PIM in 252 games (third most in P-Bruins' history). Laviolette coached Carolina (NHL) to the Stanley Cup title in 2005–2006.

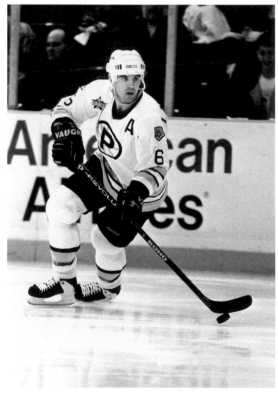

AARON DOWNEY (RIGHT WING). He is the P-Bruins' all-time penalty minute leader with 1,029 PIM. In three seasons with Providence from 1997 to 2000, the right-winger registered 47 points and 26 assists in 200 games. Downey was a member of Providence's 1998–1999 championship team. In six NHL campaigns between 1999 and 2006, he accumulated 323 PIM, 12 points, and 6 goals in 162 games.

ANDRE SAVAGE (CENTER). Savage is tied for second all-time in assists (104), ranks third all-time in points (175), and is tied for fourth all-time in goals (71) in P-Bruins' history. He also registered 217 PIM in 191 games in four years with Providence (from 1998 to 2001 and 2003–2004). Savage was a member of the P-Bruins' 1998–1999 Calder Cup–winning team. The center had 24 points, 14 assists, and 14 PIM in 66 NHL games between 1998 and 2003.

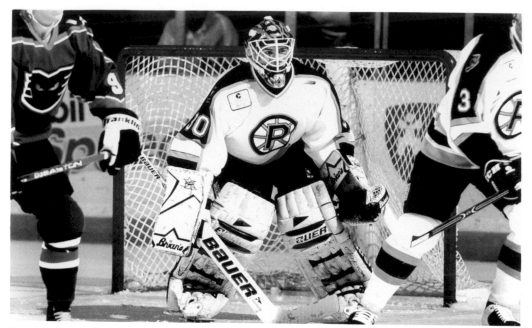

JIM CAREY (GOALIE). In two seasons with Providence from 1997 to 1999, Carey earned a 2.75 GAA and a 19-15-4 record in 40 games. He was a member of the P-Bruins' championship team in 1998–1999. From 1994 to 1999 in the NHL, the goaltender compiled a 2.58 GAA and a 79-65-16 record in 172 games. He won the NHL's best goaltender award in 1995–1996.

BRANDON SMITH (DEFENSE). Smith is tied for second all-time in assists (104) and tied for 10th all-time in points (139) in P-Bruins' history. The defenseman also totaled 35 goals and 82 PIM in 190 games from 1998 to 2001 with Providence. He was a member of the P-Bruins' 1998–1999 championship team. Smith appeared in 33 NHL games between 1998 and 2003, garnering seven points, three goals, and 10 PIM.

JAY HENDERSON (LEFT WING). Henderson appeared in the most games (278) in P-Bruins' history. He registered 119 points, 52 goals, and 891 PIM in six seasons with Providence (from 1997 to 2001, 2002–2003, and 2004–2005). The left-winger won Calder Cups with Providence in 1998–1999, Houston in 2002–2003, and Milwaukee in 2003–2004. From 1998 to 2002 in the NHL, he had four points and 37 PIM in 33 games.

RANDY ROBITAILLE PRESENTED WITH P-BRUINS TEAM AWARD. Robitaille (on the left) is tied for third all-time in assists (103) and ranks seventh all-time in points (146) in P-Bruins' history. Robitaille was named AHL regular season MVP during Providence's 1998–1999 championship season. He also scored 43 goals and registered 50 PIM from 1997 to 1999 with Providence. In the NHL between 1996 and 2006, the center had 187 points and 124 assists in 385 games.

JOEL PRPIC (CENTER). He was a member of Providence's 1998–1999 Calder Cup–winning team. The center totaled 359 PIM, 94 points, and 40 goals in 218 games with the P-Bruins from 1997 to 2000. He skated in 18 NHL games between 1997 and 2001, notching three points and four PIM. Prpic also skated in the AHL with Hershey in 2000–2001 and Cleveland in 2001–2002.

ELIAS ABRAHAMSSON (DEFENSE). From 1997 to 2001 with Providence, the defenseman had 18 points, 13 assists, and 330 PIM in 162 games. Abrahamsson was a member of the P-Bruins' 1998–1999 Calder Cup–winning team. He also skated in the AHL with Hamilton between 1999 and 2002 and spent time in the ECHL in 2001–2002.

PROVIDENCE CONTINUES TO DEVELOP BOSTON TALENT

In 2001–2002, the Providence Bruins commemorated their 10th anniversary season. The AHL also had reason to celebrate as the league was now at 27 teams in six divisions. Bill Armstrong guided the P-Bruins to a 35-37-8 record and a third place finish. Andy Hilbert was named to the AHL's all-rookie team as a forward. In the postseason, Providence lost in the qualifying series round to the St. John's Maple Leafs two games to none.

The P-Bruins captured their third division title in 2002–2003 with a 44-25-11 record. New coach Mike Sullivan was promoted to Boston (NHL) as an assistant coach late in the season and was replaced in Providence by Scott Gordon. Center Matt Herr made the first team all-stars. The locals lost in the first round of the playoffs to the Manitoba Moose, three games to one.

In 2003–2004, Scott Gordon returned as coach, and the P-Bruins finished in fourth place with a 36-33-11 mark. In the qualifying round of the playoffs, Providence lost to Portland two games to none. Center Brad Boyes was named a second team all-star. Goaltender Tim Thomas established single-season team records for shutouts (nine) and GAA (1.84).

The AHL eliminated tie games for the 2004–2005 campaign, and Providence compiled a .500 record of 40 wins and 40 losses for a fourth place finish. It was a different story in the postseason, as the P-Bruins won their first two playoff rounds—beating the Manchester Monarchs four games to two in the first round and then defeating Lowell four games to one in the second round. The Manchester series victory was the P-Bruins first playoff series win since 2000–2001. In the conference finals, the locals bowed to the eventual Calder Cup champion Philadelphia Phantoms, four games to two. Left-winger Andy Hilbert was named a second team all-star.

In 2005–2006, the P-Bruins finished in fourth place for the third season in a row, posting a winning record of 43 victories and 37 losses overall. Scott Gordon's team lost in the first round of the playoffs to Portland, four games to two.

ANDY HILBERT (WING). Hilbert is the P-Bruins' all-time leader in points (210), goals (101), and assists (109). He also amassed 296 PIM in 234 games from 2001 to 2005 with Providence. In the NHL between 2001 and 2006, the winger garnered 33 points, 15 goals, and 56 PIM in 85 games.

HANNU TOIVONEN (GOALIE).
Toivonen ranks first all-time in GAA
(2.15) and second all-time in shutouts
(nine) in P-Bruins' history. He
compiled a 44-34-7 record in 90 games
from 2003 to 2005 with Providence.
The goaltender was Boston's number
one pick (No. 29 overall) of the 2002
NHL Entry Draft. In 2005–2006,
Toivonen earned a 2.63 GAA in 20
NHL games.

CARL CORAZZINI (RIGHT WING). From
2001–2005 with Providence, the right-winger
totaled 53 points, 30 goals, and 20 PIM in
164 games. Corazzini appeared in 12 NHL
games in 2003–2004 and scored two goals.
He also skated in the AHL with Hershey
in 2004–2005 and Norfolk in 2005–2006,
and he was a member of Kelly Cup–winning
Atlantic City (ECHL) in 2002–2003.

KEVIN DALLMAN (DEFENSE). The defenseman totaled 84 points, 68 assists, and 145 PIM in 208 games during three seasons with Providence from 2002 to 2005. Dallman produced 14 points, 10 assists, and 29 PIM in 67 NHL games in 2005–2006. He played junior hockey in the Ontario Hockey League (OHL) from 1998 to 2002.

ERIC MANLOW (CENTER). Manlow is sixth all-time in points (148) in P-Bruins' history. He also produced 102 assists and 62 PIM in 176 games from 1999 to 2002 with Providence. The center skated in 37 NHL games from 2000 to 2004 and had six points, four assists, and eight PIM. He also played in the AHL with Baltimore in 1996–1997, Bridgeport from 2002 to 2004, and Grand Rapids from 2004 to 2006.

BRENDAN WALSH (CENTER). Walsh accumulated 565 PIM, 22 points, and 11 assists in 97 games from 2003 to 2005 with Providence. The center also skated in the AHL with Wilkes-Barre/Scranton in 2001–2002, San Antonio in 2002–2003, and Lowell in 2005–2006. He also spent time in the IHL in 2000–2001 and the ECHL from 2000 to 2003.

COLTON ORR (RIGHT WING). The right-winger accumulated 543 PIM, 12 points, and 10 assists in 126 games from 2002 to 2005 with the P-Bruins. In the NHL between 2003 and 2006, Orr collected 71 PIM and one point in 36 games. He also spent five seasons playing junior hockey in the WHL from 1998 to 2003.

TIM THOMAS (GOALIE). Thomas is first all-time in shutouts (11) and second all-time in GAA (2.29), and he is tied for third all-time in wins (53) in P-Bruins' history. He compiled a 53-39-11 record in 104 games during three seasons with Providence (from 2002 to 2004 and 2005–2006). In two campaigns in the NHL (2002–2003 and 2005–2006), the goaltender had a 2.79 GAA and a 15-14-0 record in 42 games.

IVAN HUML (WING). The winger tallied 123 points, 66 goals, and 196 PIM in 247 games from 2000 to 2004 with Providence. A veteran of three NHL campaigns from 2001 to 2004, Huml garnered 18 points, 12 assists, and 36 PIM in 49 games.

ZDENEK KUTLAK (DEFENSE). Kutlak played in the second most games (257) in P-Bruins' history. The defenseman had 64 points, 44 assists, and 163 PIM from 2000 to 2004 with Providence. He appeared in 16 NHL games between 2000 and 2004, tallying three points, two assists, and four PIM.

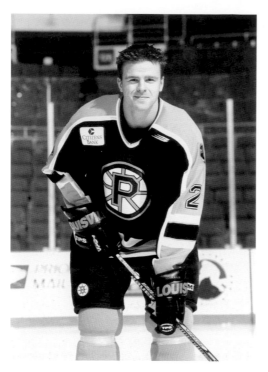

KEITH MCCAMBRIDGE (DEFENSE). He amassed 613 PIM, 12 points, and 10 assists in 169 games from 1999 to 2002 with Providence. McCambridge also skated in the AHL with Saint John from 1995 to 1998, Houston in 2002–2003, and Cleveland in 2002–2003. The defenseman also spent time in the IHL from 1997 to 2000 and the ECHL from 2003 to 2006.

ANDREW RAYCROFT (GOALIE). Raycroft is second all-time in wins (57), third all-time in GAA (2.71), and third all-time in games in goal (122) in P-Bruins' history. He compiled a 57-48-13 record with six shutouts from 2000 to 2003 and in 2005–2006 with Providence. In five NHL campaigns between 2000 and 2006, the goaltender had a 2.62 GAA and a 43-46-10 record in 108 games. He won the NHL's rookie of the year award in 2003–2004.

HONORED MEMBERS OF THE

HOCKEY HALLS OF FAME

The National Hockey League (NHL) and the Canadian Amateur Hockey Association (CAHA) founded the first Hockey Hall of Fame in September of 1943 in Kingston, Ontario, to honor the games greats. In 1958, NHL president Clarence Campbell awarded the Hockey Hall of Fame to Toronto, where it has been ever since. Today, there is still a hall of fame museum in Kingston, Ontario, called the International Hockey Hall of Fame, but player induction has only been through the Hockey Hall of Fame in Toronto since the NHL transferred its sponsorship. In 1973, the United States Hockey Hall of Fame was established in Eveleth, Minnesota, to honor American-born players, coaches, and builders of the game. In this chapter, hall of famers inducted by way of the Kingston or Toronto Hockey Halls of Fame will be referred to as have being inducted into the "NHL Hockey Hall of Fame."

Providence Reds players are well represented in both the Hockey Hall of Fame in Toronto and the United States Hockey Hall of Fame. Twenty-four players and coaches who were members of the Reds and the P-Bruins have been inducted into one of the hockey halls of fame: 20 Providence players and coaches were enshrined in the Hockey Hall of Fame in Toronto, while seven are honored in the United States Hockey Hall of Fame. Three Providence players have the distinction of being inducted into both—Frank Brimsek, Rod Langway (P-Bruins), and John Mariucci. Newsy Lalonde, Providence coach in 1931–1932, became the first Reds personnel to be inducted into a hockey hall of fame (NHL) in 1950, while Milt Schmidt became the first Reds player to be a hall of fame member (NHL) in 1961. Three members of the Reds were inaugural members of the United States Hockey Hall of Fame in 1973—Frank Brimsek, Mike Karakas, and John Mariucci. John Mariucci is the only Reds hockey hall of famer to be honored in two separate categories: as a player in the United States Hockey Hall of Fame and as a builder in the NHL Hockey Hall of Fame. Amo Bessone, John Mariucci, and Harry Sinden are the only Reds players to be inducted into a hockey hall of fame in a non-player category. Amo Bessone was elected in the United States Hockey Hall of Fame under the coaches' category, while John Mariucci and Harry Sinden were elected to the NHL Hockey Hall of Fame as builders. Rod Langway is the only Providence Bruin ever to be immortalized in either hockey hall of fame. There is also the International Ice Hockey Federation (IIHF) Hall of Fame that honors players for their outstanding play in international competition. The Reds are also represented in the IIHF Hall of Fame by Harry Sinden, who was inducted as an inaugural member in 1997.

JOHNNY BOWER (GOALIE). He is the AHL's all-time leader in wins (359) and shutouts (45) and is the only player to win three consecutive AHL MVP awards from 1955–1956 to 1957–1958. Bower had a 75-34-10 record and a 2.61 GAA in 119 games with the Reds (1945–1946 and from 1955 to 1957). The 1976 NHL Hockey Hall of Fame inductee had a 250-195-90 record, 37 shutouts, and a 2.51 GAA in 552 NHL games between 1953 and 1970.

FRANK BRIMSEK (GOALIE). Brimsek has the best all-time GAA (1.77) in Reds' history for goalies playing in at least 50 and less than 100 games. From 1937 to 1939 with Providence, he also posted a 30-18-9 record in 57 games. Brimsek compiled a 252-182-80 record, 40 shutouts, and a 2.70 GAA in 514 NHL games between 1938 and 1950. Brimsek is a member of the NHL Hockey Hall of Fame (1966) and the United States Hockey Hall of Fame (1973).

MIKE KARAKAS (GOALIE). He compiled a
110-132-28 record and a 3.66 GAA in 270 games
with Providence from 1939 to 1944 and from 1946
to 1948. Karakas was a member of the Reds'
1939–1940 Calder Cup team. The goaltender had
a 2.92 GAA and a 114-169-53 record in 336 games
during his eight-year NHL career between 1935
and 1946. The 1973 United States Hockey Hall of
Fame inductee won a Stanley Cup with Chicago
in 1937–1938.

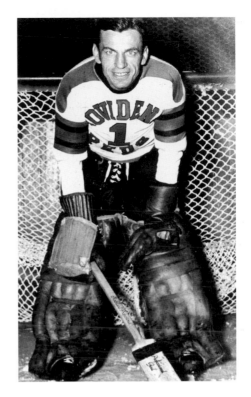

FRED "BUN" COOK (COACH AND
LEFT WING). He won the most Calder
Cups as a coach with seven, including
two with Providence, in 1937–1938
and 1939–1940. Bun piloted the Reds
for six seasons from 1937 to 1943 and
compiled a 148-137-39 (.517) record. He
skated in 37 games with Providence
over those six campaigns. The 1995
NHL Hockey Hall of Fame inductee
skated in the NHL from 1926 to 1937.

HECTOR "TOE" BLAKE (LEFT WING). He won 11 Stanley Cups: three as a player and eight as a coach. He accumulated 527 points and 235 goals in 14 NHL seasons from 1934 to 1948. In 1935–1936, he had 23 points and 12 goals in 33 games with Providence. Toe had an NHL coaching record of 500-255-159 (.634) from 1955 to 1968 with Montreal. He was inducted into the NHL Hockey Hall of Fame in 1966.

SPRAGUE CLEGHORN (COACH). He coached Providence to its first Fontaine Cup championship and first regular season title in 1929–1930. Cleghorn piloted the Reds to a 67-28-17 (.674) record from 1929 to 1931. Prior to piloting the Reds, he played 10 seasons in the NHL from 1918 to 1928, garnering 138 points, 83 goals, and 538 PIM in 259 games. He was inducted into the NHL Hockey Hall of Fame in 1958.

JOHN MARIUCCI (DEFENSE). He was elected into the NHL Hockey Hall of Fame as a builder in 1985 and was an inaugural inductee of the United States Hockey Hall of Fame as a player in 1973. The name Mariucci was synonymous with the growth of amateur and professional hockey in Minnesota for over 40 years. In 1940–1941 with Providence, he had six points and three goals in 17 games.

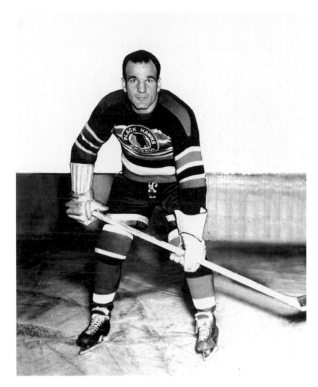

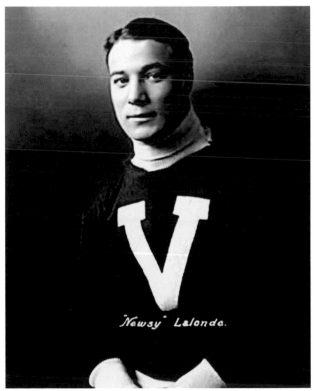

Newsy Lalonde.

NEWSY LALONDE (COACH). In 1931–1932, he coached the Reds to a Fontaine Cup championship and a CAHL regular season championship with a 23-11-6 (.650) record. Lalonde spent six seasons in the NHL between 1917 and 1927 and tallied 165 points and 124 goals in 99 games. He was a member of the Canadiens (NHL) first Stanley Cup–winning team in 1915–1916. The center was a 1950 NHL Hockey Hall of Fame inductee.

WOODY DUMART (LEFT WING). He was elected into the NHL Hockey Hall of Fame in 1992. Dumart had 429 points and 211 goals in 772 games and won two Stanley Cups with Boston (1938–1939 and 1940–1941) during his 16-year NHL career between 1935 and 1954. In his two seasons with the Reds in 1936–1937 and 1954–1955, the left-winger had 15 points, 9 assists, and 10 PIM in 49 games.

BOBBY BAUER (RIGHT WING). Bauer played with the Reds during their first American League season in 1936–1937. He had 18 points and 14 goals in 44 games with Providence. A member of two Boston Stanley Cup–winning teams in 1938–1939 and 1940–1941, the right-winger had 260 points and 123 goals during nine NHL seasons between 1936 and 1952. Bauer was inducted into the NHL Hockey Hall of Fame in 1996.

MILT SCHMIDT (CENTER/DEFENSE). In 1936–1937 with Providence, Schmidt had nine points and eight goals in 23 games. In 16 NHL seasons between 1936 and 1955, the 1961 NHL Hockey Hall of Fame inductee had 575 points and 229 goals in 776 NHL games. He won two Stanley Cups with Boston in 1938–1939 and 1940–1941. Schmidt coached in the NHL for 13 seasons and compiled a 250-394-126 (.406) record between 1954 and 1976.

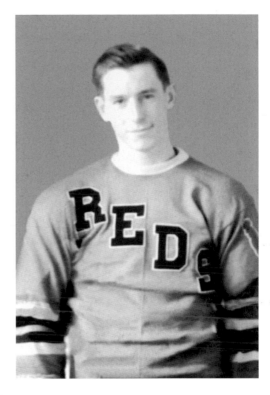

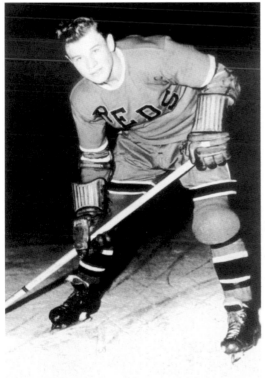

BILL MOSIENKO (RIGHT WING). He scored the fastest three goals in NHL history (21 seconds) on March 23, 1952, as a member of Chicago. The NHL's 1944–1945 most gentlemanly player award winner tallied 540 points and 258 goals in 711 games from 1941 to 1955. The 1965 NHL Hockey Hall of Fame inductee played with Providence in 1940–1941 and garnered 33 points and 14 goals in 36 games with the Reds.

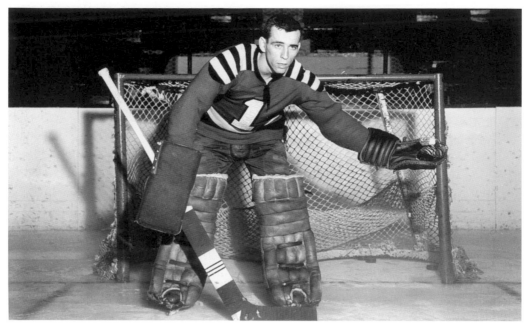

EDDIE GIACOMIN (GOALIE). The 1987 NHL Hockey Hall of Fame inductee earned a 109-129-10 record, 12 shutouts, and a 3.57 GAA in 251 games during six seasons with Providence from 1959 to 1965. In his 13-year NHL career from 1965 to 1978, the goaltender compiled a 2.82 GAA, 54 shutouts, and a 289-209-96 record in 609 games. He also shared NHL best goaltender honors in 1970–1971.

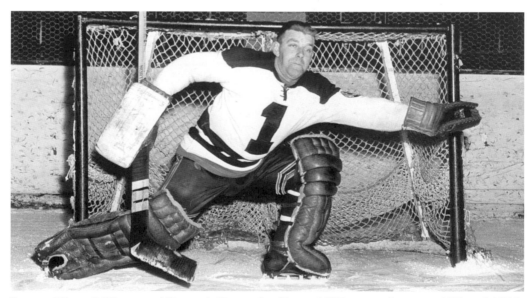

LORNE "GUMP" WORSLEY (GOALIE). During his 21-year NHL career (between 1952 and 1974), the 1980 NHL Hockey Hall of Fame inductee had a 2.88 GAA, a 335-352-150 record, and 43 shutouts in 861 games. In the NHL, Gump won four Stanley Cups, shared the best goaltender award twice, and was named rookie of the year. In 1957–1958 with Providence, the goaltender had a 3.26 GAA and a 12-11-2 record in 25 games.

FERN FLAMAN (DEFENSE/COACH/GENERAL MANAGER). He compiled a 126-146-14 (.465) record in four seasons piloting the Reds from 1961 to 1965. Flaman acted as player/coach with Providence from 1961 to 1964, producing 63 points, 55 assists, and 181 PIM in 155 games. The defenseman accumulated 1,370 PIM and 208 points during 17 NHL seasons from 1944 to 1961. Flaman was inducted into the NHL Hockey Hall of Fame in 1990.

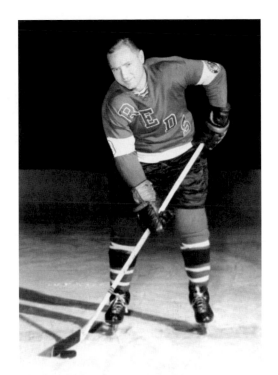

KEN YACKEL (RIGHT WING). Elected into the United States Hockey Hall of Fame in 1986, Yackel had 84 points and 30 goals in 123 games with the Reds from 1958 to 1960. He coached the United States National Team at the World Championships in 1965 and was a member of the United States silver medal team at the 1952 Olympics. Yackel had a stint in the NHL in 1958–1959.

HARRY LUMLEY (GOALIE). In 1958–1959, he had a 3.59 GAA, a 27-29-2 record, and four shutouts in 58 games with Providence. The 1980 NHL Hockey Hall of Fame inductee had a 2.75 GAA, a 330-329-142 record, and 71 shutouts in 803 games during 16 NHL seasons between 1943 and 1960. Lumley was a member of Stanley Cup champion Detroit in 1949–1950 and won the NHL's best goaltender award in 1953–1954.

ALLAN STANLEY (DEFENSE). A veteran of 21 NHL seasons from 1948 to 1969, the 1981 NHL Hockey Hall of Fame inductee tallied 433 points and 333 assists in 1,244 NHL games. Stanley was a member of all four Toronto Stanley Cup teams in the 1960s. The defenseman played three seasons with Providence from 1946 to 1949 and had 85 points and 24 goals in 145 games. He skated for the Reds' 1948–1949 Calder Cup–winning team.

MAX BENTLEY (CENTER). Bentley was a member of three Stanley Cup–winning teams with Toronto (1947–1948, 1948–1949, and 1950–1951). Elected into the NHL Hockey Hall of Fame in 1966, the center amassed 544 points and 245 goals in 12 NHL seasons between 1940 and 1954. Bentley played with the Reds during the 1940–1941 season and had six points and four goals in nine games. He won the Hart Memorial Trophy (NHL's regular season MVP) in 1945–1946.

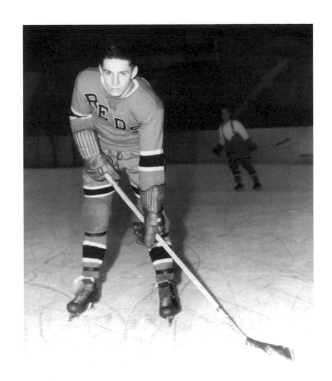

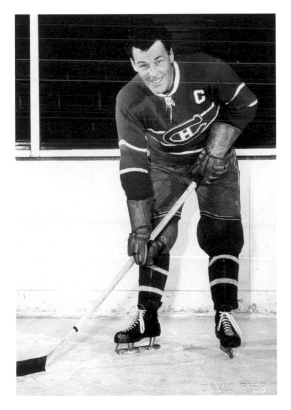

EMILE "BUTCH" BOUCHARD (DEFENSE). The 1966 NHL Hockey Hall of Fame inductee had 193 points, 144 assists, and 863 PIM in 785 games during his 15-year NHL career from 1941 to 1956. Butch was a member of four Stanley Cup–winning teams with the Canadiens (1943–1944, 1945–1946, 1952–1953, and 1955–1956). In 1940–1941 with Providence, the defenseman had four points, three goals, and eight PIM in 12 games.

HARRY SINDEN (DEFENSE). Inducted as a builder into the NHL Hockey Hall of Fame in 1983, Sinden skated in one game with Providence in 1963–1964. Sinden was Boston's general manager from 1972 to 2001 and piloted the team for six seasons between 1966 and 1985, including a Stanley Cup title in 1969–1970. He is also an inaugural inductee of the IIHF Hockey Hall of Fame (1997).

ROD LANGWAY (DEFENSE). A member of both the NHL Hockey Hall of Fame (2002) and the United States Hockey Hall of Fame (1999), Langway produced 329 points and 278 assists in 994 NHL games from 1978 to 1993. He received the NHL's best defenseman award twice (1982–1983 and 1983–1984) and won a Stanley Cup with Montreal in 1978–1979. The defenseman played 10 games for the P-Bruins in 1997–1998.

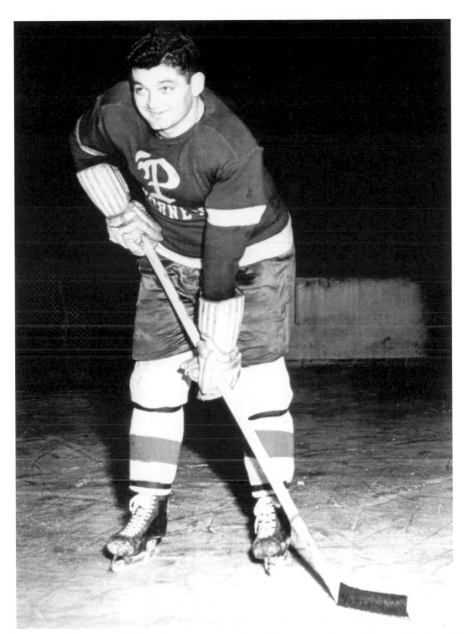

PETE BESSONE (DEFENSE). Pete Bessone was elected into the United States Hockey Hall of Fame in 1978. Bessone played with Providence in 1946–1947 and had 13 points, nine assists, and 94 PIM in 54 games. Bessone had a stint in the NHL during the 1937–1938 campaign. He spent most of his career in the American League between 1937 and 1950 and won a Calder Cup with Cleveland in 1944–1945. His brother is hall-of-famer Amo Bessone. Amo Bessone (defense) was enshrined in the United States Hockey Hall of Fame in the coaches' category in 1992. Amo spent 28 years as hockey coach of Michigan State University from 1951 to 1979, compiling a 367-427-20 (.463) record and winning a national championship in 1965–1966. Amo skated with Providence from 1942 to 1944 and in 1945–1946, garnering one point and 18 PIM in 17 games.

ACROSS AMERICA, PEOPLE ARE DISCOVERING SOMETHING WONDERFUL. *THEIR HERITAGE.*

Arcadia Publishing is the leading local history publisher in the United States. With more than 3,000 titles in print and hundreds of new titles released every year, Arcadia has extensive specialized experience chronicling the history of communities and celebrating America's hidden stories, bringing to life the people, places, and events from the past. To discover the history of other communities across the nation, please visit:

www.arcadiapublishing.com

Customized search tools allow you to find regional history books about the town where you grew up, the cities where your friends and family live, the town where your parents met, or even that retirement spot you've been dreaming about.